# STREET ART UNCUT

**Matthew Lunn**

CRAFTSMAN HOUSE

## DEDICATION

Anusha and Ashwin: you have both put up with me spending many nights and days constructing pages and cursing my computer (which deserved to be cursed). Thank you for giving me the time, helping me by reading and viewing many pages, and being patient with me while I completed this personal project.

Thank you to all who have taken the time to sign the street while moving through it.

**Local knowledge**
Ha-Ha, MIC, Phibs, Sumo & Ghostpatrol and the many other writers who helped, I couldn't have done it without you.

**Additional Photos**
Bailer, Ghostpatrol, Reka, Scottie and Numskull, thankyou for providing extra photos.

# A Melbourne street artist 's passion

"I do this so I don't go insane in my day job. I have been interested in graff since about fifteen when I started hanging out with Cave Clan boys. I just sort of dabbled in it to pass the time going through uni, but always focused on drawing characters. I did a visual arts degree at uni but didn't do art for about three years after finishing. I started work in the city and began noticing stencils as they would give me a laugh on the way to work every morning. I saw all the character stickers up and thought I may as well start transferring some of my characters to stickers. My first stickers were getting ripped down so I got a little disheartened and stopped for a bit. I thought it was because they were crap, but looking back now, they were the best characters I ever did!

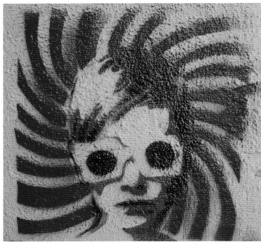

"My housemate was making stencils and asked me to give him a hand one day. I cut that twiggy one with the swirly background in North Melbourne that you have a pic of and was totally hooked It's a really addictive thing. That particular stencil was the first stencil I ever sprayed on the streets, even though my housemate thought I was crazy for attempting a multi-layer as my first stencil. Anyway, it became a little obsession and from then on, every spare minute at work has been taken up surfing the net for ideas, creating new stencils or drawing new stickers, and as soon as I get home I drop my bag and do more. It's become so addictive I can't watch TV or just sit there for more than five seconds before I am bored. Just the feeling that someone is seeing my art and appreciating it is motivation enough to keep doing it, because when you are doing it for yourself you tend not to be as enthusiastic. There is no real point to it and you never know if your stuff is any good. The great thing about this scene is you get lots of great feedback and it is a really close knit community so I guess it makes you feel as though you're part of something and you're doing something worthwhile. I've met so many great people too, here and overseas, that have become good friends and it has given me more opportunities in art than uni ever did, to exhibit and be part of different projects which I would never have had the opportunity to do."
*Aryze, Melbourne street artist*

# Introduction: The Challenge of Street Art

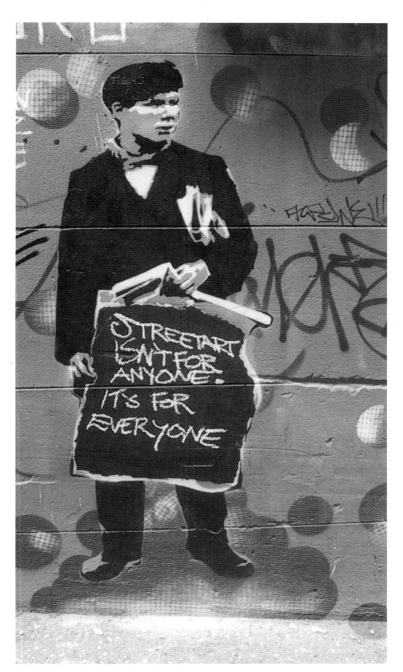

*Street Art Uncut* challenges the reader to notice the art of the street.

As with other forms of art and language, to fully appreciate street art you must make a conscious decision to step back and really see it, hear its tones and understand its nuances. Being confronted by graffiti can be as irritating as sitting next to someone with music blaring out of their headphones: you have no choice about whether or not you experience the sight or sound. But most people enjoy, or at least appreciate, street art once they have been introduced to it.

This book does not justify, condemn or condone street art, although it does often celebrate its artistic qualities and its wit. It does not intellectualise it – you won't find complex terminology like ebonics or logoclasm. Instead, it is designed to help readers see street art from a number of angles.

For individual artists, street art is an expression of their personalities and a testimony to their artistic skills and growth. I love watching the development of an artist's work, and trying to interpret the meaning of his or her creations.

Mostly, street art is a form of expression and a statement of identity, but there are many varied reasons artists choose this form of creativity. Understanding what motivates each artist is another challenge, but the artists are elusive and suspicious when approached. This is no surprise – street art is mostly illegal, so they have to be careful about who they talk to and what they say.

Street art can also be considered at a collective level: I think of it as reading an essay on social behaviour. You can see trends in behaviour and creative expression. Street art captures the politics, cult figures and images of a moment in time, and it tells stories of love and loss.

*Street Art Uncut* also looks at some of the behaviours, rules and structures in the street art subculture, many of which are the same as the broader society of which it is a part.

Street art impacts us all in different ways. This book also looks at the perception of street art, whether negative, positive or indifferent.

What makes Melbourne so fascinating is the huge diversity of art, and the constant swinging pendulum of styles. I have been consistently surprised by the diversity of styles and the speed of evolution of different trends.

I will always be looking to see what is out there as it changes so frequently, from one week to the next. I hope that after reading this book you will do the same. Perhaps you will find yourself inspired by some of the creations you see as you look out a train window on your way to work, or as you walk down an alley in the city. You may not consider all of it to be art, but I believe you will enjoy the experience and the challenge.

# Expression versus perception

Everyone has a desire to express themselves. It may be through how they dress, where they hang out, the place they live, or the people with whom they choose to spend time. Many of us also choose ways to mark our environment, personalising the world outside, by decorating our houses or cars, for instance. We are drawn to putting our signature into the public domain as a small mark of our innate uniqueness, our identity.

Street art is one way for people to express themselves and to mark the landscape. Street artists choose a very public outlet for their creativity. Graffiti is a hugely expressive medium, limited only by the artists' time, money, skills and their readiness to take risks. Artists may also create street art to associate themselves with their peers, to rebel, or to be able to speak their mind without censorship. Street art may be a statement: a cryptic message that is targeted to a narrow audience, or a public declaration on life and politics. It can be humorous or threatening, satirical or serious. Mostly, though, expression through street art in Australia is about artists getting their work seen and asserting their identity.

In the modern world, graffiti is one of very few contemporary forms of expression that retains the ability to be shockingly evocative. We are becoming desensitised to events, information, and more conventional forms of art. A piece of graffiti might provoke any manner of response: interest, disgust, amusement, anger, admiration.

It seems a shame that many people walk blindly past.

One of the most engaging things about street art is that it is unedited. It has a rawness you don't get through other forms of media. It is the voice of the world around us.

Most street art is illegal and much of it challenges viewers. It is experimental and innovative. It often provides a starting point for some extremely talented designers. It can be ugly or beautiful. Your reaction to it will always comes back to a subjective judgement: how do you perceive it?

# Defining street art

The term 'street art' remains formally undefined. It is not in any dictionary or thesaurus I have seen. So I have used the terms 'artless', 'art' and 'graffiti' to come to my own definition.

I particularly like the term 'artless' because it reflects the attitude many people have towards street art, especially when they are sitting on a train surrounded by unsophisticated and crude 'tags' sprayed, drawn and scratched on the doors and windows. Also, many people don't consider street art to be art simply because it is illegal. But I most like 'artless' because the term's more formal definition (see below) is often a good description of street art.

However, almost always street art involves artistic talent. In each of the genres of street art there is a specific set of skills required that must be developed through practice. Many of these skills are recognised by the public when they are used in creative occupations such as graphic design, and are often identical to those used by traditional artists. More than anything, what makes street art fit the definition of art is the way artists create something new from their imaginations, something that affects the viewer's aesthetic sensibilities.

Graffiti is a sub-genre of street art, although the terms are often used as synonyms. Strictly speaking, graffiti is a collection of marks made directly onto a wall. These days such marks might be a written message of love or a political statement. Graffiti might be a signature-like tag or the more polished version – a throw-up. The marks might be as complex as an entire mural.

This book classifies street art according to the style of work and the method used to create it. The following pages provide a brief introduction to sub-genres of graffiti such as tags, throw-ups, and pieces, as well as to other forms of street art such as stencils, stickers, paste-ups, sculptures and plaques.

**These definitions of street art can paradoxically lead to work which is both art and artless at the same time.**

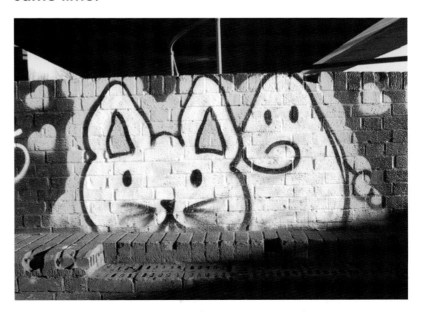

---

### Art
Art is defined as requiring skills, imagination and judgement. Art requires the development of skills through experience to consciously produce colours, sounds and movements that affect our sense of beauty.

### Artless
Artless means guileless, crude and clumsy or even uncultured. At the same time, something that is artless is natural, free from artificiality or affectation.

### Graffiti
Graffiti is writing or drawing scratched or scribbled onto surfaces, predominantly walls, in public places. It is almost always unauthorised.

## Tagging

A tag is the most basic form of a graffiti-style signature. It is usually textual, a stylised, practised and ritualistic method of writing, but some graffers adopt a character or symbol. Tagging is typically done with a fat-tipped texta or a spray can. Pens and textas are usually used indoors, inside trains; in toilets and on windows, spray cans are used outside. Taggers often have the least respect for personal property. Often ugly, tagging is the most universally disliked form of graffiti. But creating tags is the starting point for almost all graffiti writers, and is where most muralists and piecers begin to develop their style, making it an unfortunate but necessary stage. Like most graffiti, it is about identity, a way of proclaiming: "this is who I am".

## Throw-ups

Throw-ups, another declaration of identity, are typically big, rounded letters or icons, surrounded by a thick border colour, and filled in rapidly with broad strokes of a single colour. They take very little time, and use comparatively little paint, so they are a quick fix for a writer. They could be seen as a quick and dirty piece or a more refined tag; they are both and neither. Writers often learn to piece by spraying throw-ups. A good 'throwey' has style. Renks is a throw-up master rivalled only by Bones and SK.

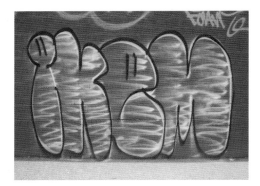

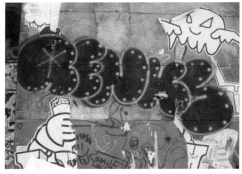

## Pieces

This is where graffiti starts to get more sophisticated. Pieces are complex and detailed, covering a large surface area (usually more than thirty square metres), and thus taking longer to complete. Often high quality, they are typically done in freehand style using a spray can and

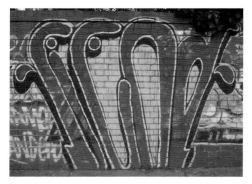

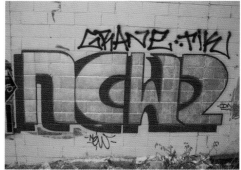

and occasionally a stencil to assist (although this is frowned upon by purists). Piecers often have serious artistic talent, and can take tagging and throw-ups to an entirely new realm. The art is still an assertion of identity, but the focus is on style and artistry.

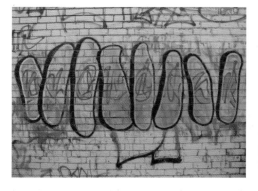

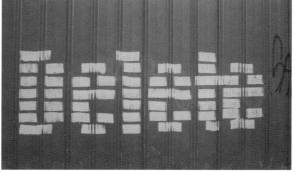

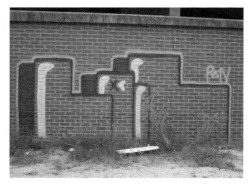

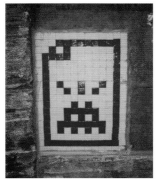

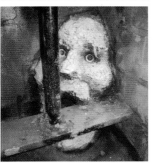

## Sculpture and plaques

The three-dimensional forms of street art, sculptures and plaques are rarities. Sculpture is particularly uncommon, as it is often prepared on-site, responding to and using its environment. If it was created elsewhere and then placed in the street we would see more of it. Another reason for its scarcity is that it is more obvious and thus more likely to be removed. To counter this, sculptures are tucked away in corners.

In contrast, plaques are typically prepared off-site. The plaque itself can be anything: old board, paper, or a floppy disk. Even items such as Rubik's cubes (as shown top left) and car bonnets have been used. An image is usually drawn on the plaque with a texta or spray can, using stencils or freehand. The pixelated invader shown here is based on the '80s computer game Pacman and can be found all over the world.

## Paste-ups and stickers

Paste-ups, or posters, are sheets of paper stuck to the wall, while stickers, generally smaller, come with their own adhesive backing. Both allow mass-production, especially if the artwork is created on a computer and then transferred to blank paper or stickers. But they can also be hand drawn on- or off-site. Paste-ups can be the entire sheet or a cut-out image.

Posters and stickers attract a less severe penalty than drawing directly onto a wall or other surface, and so are safer forms of street art. The paste-ups shown here are by Melbourne-based graphic designer Psalm. The clean-cut style is the mark of a design professional.

## Stuckistry

Stuckistry refers to the use of stencils to produce images, which are themselves called stencils. Brightly coloured stencils adorn the streets of Melbourne, and have done so in large numbers for several years. Many stencils are hand-drawn but most are created using computer software. Those that are derived from an electronic image are modified to make them less detailed and thus less complex to reproduce. Once simplified in this way, the artist cuts out the appropriate shape to create the desired stencil. Stencils created for the street tend to be done in spray paint, while those for universities tend to be done in chalk. Stencils can be single or multi-coloured.

They may stand alone or be next to or part of other works where the use of drips, plaques and text are often incorporated.

# Legal versus illegal street art

Can legal graffiti be defined as graffiti? Your answer will depend on your perception of street art. The public often considers legal pieces as clever art and illegal pieces as vandalism. On the other hand, street artists themselves will regard legal walls as 'soft', as there is no risk in generating the work.

Creating art on legal walls can be attractive to street artists because it gives them a chance to show their skills to a wide audience. The quality of street art on legal walls is often high. Artists have more time to concentrate on their work, especially as they don't need to keep checking over their shoulder for the authorities. But without the adrenalin rush than comes with breaking the law, some question whether the art will be as inspired. Many street artists see risk taking as integral to the creative process

Illegal graffiti can provide a pathway to legal street art. The legal murals included throughout this book are all painted by writers 'trained' on the street. The quality of the artwork is self-evident, and if the artists hadn't started out illegally it might never have been created.

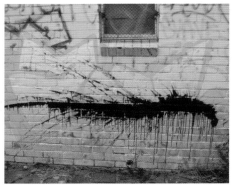

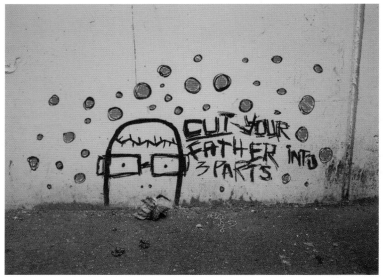

Legal, or at least graffiti tolerant, areas abound in Melbourne. Graffiti rich areas, like the city's Hosier Lane, are almost a public street art free-for-all. Melbourne City Council and other inner city councils are constantly considering new approaches to graffiti 'management'.

As well as having sanctioned spaces for street art, Melbourne has seen over a dozen graffiti-specific exhibitions at showrooms all over the CBD and the inner suburbs. All of them have been profitable and packed with a diverse crowd of people, not just street artists checking out rival styles. Graffiti is appreciated by a wider audience than one might expect.

Legalised walls and tolerant areas will only ever work for a select few writers. The hardcore are as likely to blitz the area immediately on the boundaries of a legal area, a proverbial two fingered salute.

The pieces shown throughout this book are mostly illegal works.

# New York, Paris, London... and Melbourne?

Melbourne has become a leading light in the world of street art. It now plays a key role in innovative developments within the global scene and has a reputation that attracts international and interstate artists to add their mark, and brings in tourists who want to view the artwork.

Street art flourishes in Melbourne despite the fact that, like so many other Western countries, Australia is becoming increasingly right wing and conservative. It is also geographically remote from other centres of street art culture and has a relatively small population, especially given its geographical size.

However, Melbourne is blessed with large numbers of creative people, perhaps thanks to the ever increasing numbers of people studying at the many tertiary institutions in the city. As well, Melburnians have that typical Aussie attitude encapsulated by the phrase 'she'll be right, mate', with the implication that everything will work out OK, and things are best left alone. This attitude can mean that many Australians are politically apathetic. While this may mean political graffiti is rare, the graffiti that is generated is potentially open to greater artistic expression.

Other Australian cities share these qualities, but have a zero (or near-zero) tolerance approach to graffiti. In Sydney and Adelaide, for example, it is removed or buffed within about 48 hours. But Melbourne has a quasi acceptance of graffiti, by both the authorities and the public, that is almost the antithesis of the approach taken in other Australian cities.

In Melbourne, street art can sit untouched for days, sometimes months. One piece in Melbourne is being considered for heritage listing. The City of Port Phillip, which incorporates the inner city suburb of St Kilda, organised graffiti writers to blitz the pedestrian walkways under its main traffic intersection (see top right) and even invited several key writers to paint the entrance hall to the council chambers.

So why is Melbourne such a productive city for street art? Mostly, I think, because of that tolerance, but also because the opportunity is there, in terms of ease of access to a vast amount of space.

Over the last twenty years, Melbourne's inner city suburbs have undergone a rapid process of gentrification. Areas which once housed mainly docklands, warehouses,

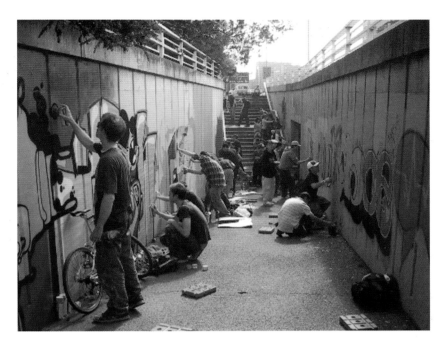

factories and industrial centres are now busy residential neighbourhoods too. As people increasingly make these areas their home, the canvasses provided by these types of buildings become both more accessible and more desirable to street artists.

The Melbourne rail network also provides opportunities for graffers. The system covers much of the city and there is little or no disincentive to wander along the lines. This greatly increases the space available to artists. Because these areas are not heavily policed, and it is relatively easy to escape if the police do appear, the larger, more complex pieces tend to be trackside.

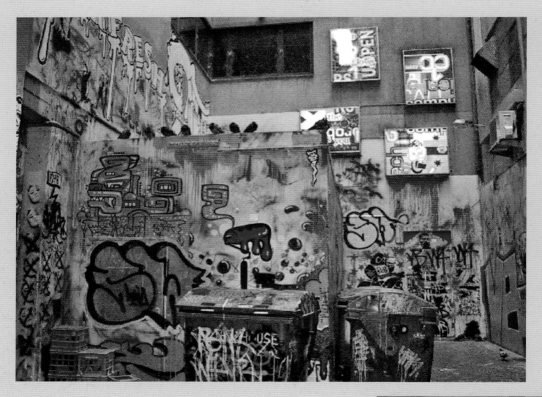

## Melbourne's laneways

The city's heart, the Central Business District, was built as a colonial heartland in the gold rush days. The city is full of narrow cobbled lanes and cubby holes, forming perfect canvases tucked out of direct lines of sight. Melbourne's laneways are fertile ground for street art.

Many graffiti surveys show that some members of the public compare graffiti with dog-fouling and littering, suggesting that it is an equivalent type of uncivil behaviour that negatively affects an area's image. Such surveys reveal an attitude that the environment is "unmanaged and uncared for". But the graffiti-blitzed walls of Melbourne's CBD (Centre Place in this example) are about as far from an uncared for and unmanaged environment as a laneway can get.

The art displayed here is not necessarily to everyone's taste, but it is bright, entices you in, and rewards your curiosity. The graffiti artists execute well-planned painting sessions at this type of site. Their work attracts publicity and people, including tourists.

When taking these photographs, I was asked by a visitor from Perth if I could take her on a guided tour of Melbourne's main graffiti sites. I gladly obliged. She was a recent retiree, visiting a daughter in Melbourne who was equally fascinated by the design and artistic talents freely available for viewing on walls and in other public spaces.

I have also been stopped by children as young as six who wanted to "do picture graffiti" when they grew up.

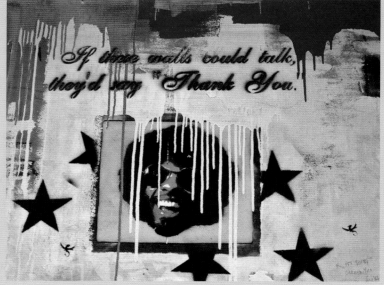

Brunswick

Coburg

Northcote

Collingwood

Fitzroy

West City Lanes

Little, Latrobe, Lonsdale
and Elizabeth Streets

Little
Bourke
Lanes

Carlton

Centre
Place

Hosier Lane

Central City Lanes

Flinders St Lanes

Docklands

South City

Hosier Lane

Richmond

Melbourne's Central Business District and surrounding suburbs. Where to go and what to see.

## Northern suburbs

The suburbs north of Melbourne are home to a vast network of local artists. As you move away from the city through Fitzroy and Collingwood, keep an eye out for the many walls and hidden lanes, which may feature work by Peazor, Optic, Bones and Tusk, among others. Focal points include Coburg, Northcote, Brunswick, Collingwood, Fitzroy, Carlton, North Melbourne and Essendon. Look for the streets bordering Brunswick Street (Fitzroy), Canada Lane (Carlton), and Sydney Road (Brunswick and Coburg). There are also major sites along the Upfield rail line from Jewell to Coburg stations and the Epping and Hurstbridge rail lines out to Thornbury and Dennis stations respectively.

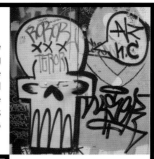

## General hints

Want to find graffiti? Walk or cycle. Much of it is easily accessible, but not by car. All of the railway lines have cycle paths that follow the route. If photographing along rail lines you will need a reasonable camera as the art may be on the opposite side of the track. Once you have tapped in to the subculture, you will 'sense' graffiti and find it easily. Cobbled streets and alleyways behind warehouses are public walkways and often lead to new pieces. Car parks and public parks are also good places to look.

### Central Business District

The city centre has dozens of little laneways, many of them havens for street art, many of them unfamiliar to the majority of the city's residents and workers. Melbourne is relatively safe to explore. As well as graffiti, you will find a lot of history tucked away behind buildings.

On a busy weekend is not unusual to see anything up to sixty artists blitzing a wall in the heart of the city. The police tend not to bother – or perhaps they think a legal, commissioned piece is going up.

If you want to explore, look out for Centre Place, Little La Trobe Street, Hosier Lane, Duckboard Place and the laneways off Bourke Street. Two of my favourites are Caledonian Lane and Corporation Lane, with the former housing a great watering hole.

## Eastern suburbs

If heading east, keep your eyes peeled for the prolific works of Sync, Reka and Prism. Key stencil areas are the suburbs of Richmond, Abbotsford, South Yarra and Prahran. Follow the railways heading to Frankston, Glen Waverley, Alamein and Lilydale: the line between Richmond and Malvern, accessible from cycle paths, is particularly rich. Murrumbeena Station has graffiti by Shime, some of the most complex I have seen. KSA, SDM and CTM are among the main crews to blitz the rail lines. Seaford Substation and other derelict buildings hold vast reservoirs of untapped spaces and unseen art.

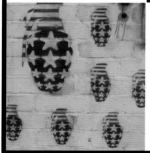

## Docklands & southern suburbs

Docklands, on the south-western fringe of the city, was a wasteland of huge warehouses. The area is now gentrifying. You will find legal graffiti exhibitions of great quality in warehouses, and other commissioned street art. Established southern suburbs such as South Melbourne, Port Melbourne and St Kilda are also home to plenty of street art. If you are looking for quality graffiti, cycle along the Sandringham rail line from Prahran to Brighton and beyond. Stop off in St Kilda and East St Kilda for stencils. The tramstop junction on St Kilda Road is very busy. Watch out for work by Bailer and MIC.

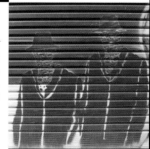

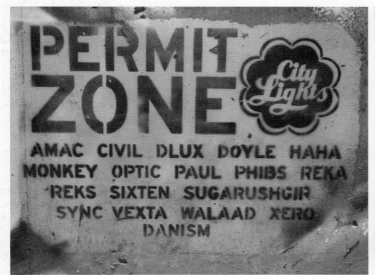

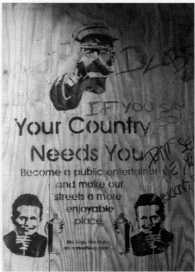

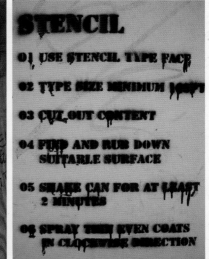

# The rules of engagement for a street artist's survival

Like any subculture, the world of street art has rules that dictate appropriate behaviour. These unwritten rules are basically the same across all genres of graffiti and relate to where it is OK to write and where it is not. Those who break the rules can be beaten, scorned or shunned and will be referred to as a 'toy', the bottom of the food chain in graffiti speak.

Graffiti can be written on anything regarded as public, which typically includes warehouses, government and public buildings, and any form of public transport. Private houses, heritage sites, graveyards and old people's homes are regarded by most as out of bounds. Cars in particular are no-go zones. Those who use them are preyed upon and ridiculed.

Writing over the top of another artist's work will also cause some hassle. The hassle might be as minor as the offending party having every piece they ever write being tagged or ruined by the artist whose work was overwritten. At worst, such behaviour might trigger violence.

Competition for the best spots can be fierce, and occasionally inter-crew fights will involve weapons, but generally there is not much violence. Still, it pays to know the names of the crews and their reputations. There is no point triggering a fight if you are not prepared to have one, or don't have people to back you up. Graffiti can be dangerous – but your behaviour can make it less so. If you want to avoid a fight, find your own space and don't overwrite another artist's work.

Many writers, particularly those who use the railway lines, work with others as this affords them a certain amount of protection. Working in groups means more people to look out for authority figures and oncoming trains, and friends can help carry extra paints and offer a critical eye.

One of the aspects of street art that makes it most appealing for the vast majority of writers is the social aspect. Melbourne's street art culture is a huge social scene. The artists have specific meeting places and studios in a number of locations, they meet regularly socially for exhibitions and parties.

The graffiti culture and network is expansive, numbering dozens of crews, and probably a few hundred regular writers in Melbourne alone. There must be similar numbers of stencil, sticker and poster guys, but they tend to operate more independently of each other than the graffiti crews. The networks maintain contact through mobile phones, tag names, and websites.

Street language develops in parallel to graffiti: the street artist both feeds and feeds off the language of the street.

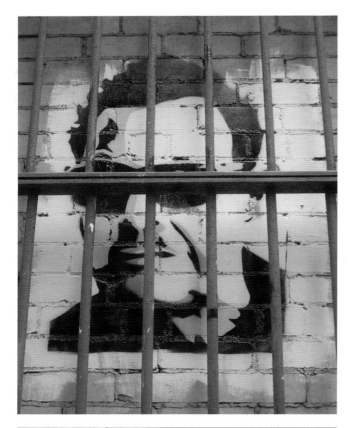

# The street artist - a profile

Because street art is usually illegal, the public often has a fixed and negative perception of street artists.

In fact, street artists defy stereotyping. They live in every suburb: affluent, underprivileged and in between. They may be studying at university or they might have dropped out of high school. They may be in and out of jail or working at an executive level in large corporations.

Even so, there are some common themes. Typically, writers are between 12 and 30 years old, with the majority younger than 18. And although some street artists are women, the vast majority are men. Writers give clues as to who they are. Their works tend to appear in highest densities close to their homes, while their style reveals aspects of their personality, how they view life and who they associate with.

There is no conclusive evidence to show that street artists commit other crimes, in fact it is more likely that many artists benefit from the development of skills that can be used in professional careers. Street artists seem on the whole to be creative rather than aggressive, and research has shown that violence is not associated with graffiti artists, apart from the occasional rivalry between crews.

My experience suggests that street artists in general, or at least those who are most prolific, are in fact very stable, clued in and in control of their worlds. Many of the older Melbourne writers are successful socially as well as in their own businesses or jobs in corporate firms. Many of Melbourne's street artists are designers by profession.

It is true, though, that street artists are engaged in an illegal activity. Spray-painting directly onto a wall is a crime, so offenders may end up with a criminal record as well as a stiff financial penalty. Other forms of street art which involve pasting or mounting something on to a wall are less risky: as the damage to property is reduced, so is the penalty that goes with it, and an offender may avoid a criminal record.

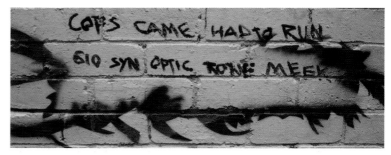

These guys had to bolt when disturbed by police, nearly getting caught in their efforts to scramble away over fences and through back gardens.

# Graffing for life!!

This map illustrates how different forms of graffiti are related to each other, and the possible entry and exit points for artist of various types. Many artists jump from one genre to another at will. The numbers do not necessarily represent the order of progression, but provide the key to the definitions below.

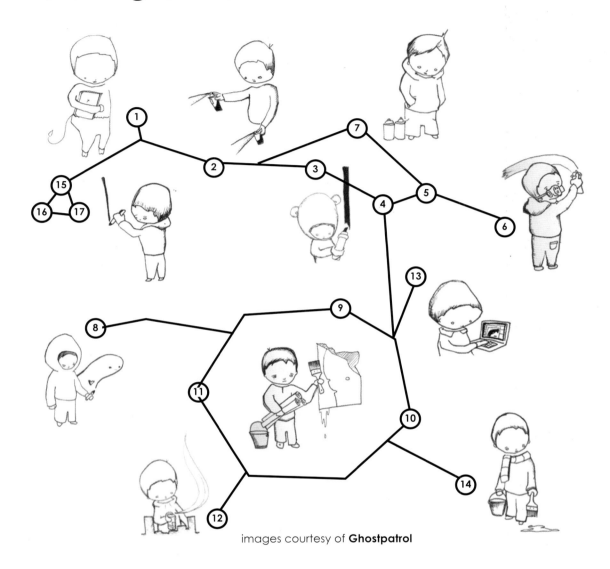

images courtesy of **Ghostpatrol**

**1 . School book doodler**
First sketches and identifying tags
**2. Tagger or bomber**
Tags moved onto the street
**3. Throw-up specialist**
Specialised tags
**4. Toy-piecer**
Cutting first pieces
**5. Piecer**
Established writer
**6. Professional piecer**
Mostly legal or commissioned work
**7. Gang boy**
Tags/pieces within crew only
**8. Your average Joe**
You and me
**9. Cartoonist**
Characters and animation
**10. Poster and paste-up guy**
Pasting onto walls
**11. Sticker guy**
Designed or hand-drawn stickers
**12. Street art professional**
High-profile and established
**13. Graphic designer**
Can work a computer
**14. Conventional artist**
Also dabbles in street art
**15. Late night drunk**
Toilet graffiti
**16. Social conscience**
Them that care about us
**17. Political activist**
A rarity in Australia

Artists and writers become involved in street art and graffiti for different reasons: some because their friends and siblings were doing it, some through peer pressure, others simply because they were bored. Once in the scene, artists find it addictive. It is naughty, anti-establishment and provides a buzz. It is a perfect act of rebellion, and a fantastic method for uniquely identifying oneself and communicating with friends in a private code. Most artists drop out of the scene without turning professional, but many end up in particular careers. For example, those artists who have developed strong computer-based skills are able to continue using these skills in the workplace, often in graphic design–based jobs. Their artwork may well continue to pop up on the street in ever more sophisticated forms.

Graffiti is not so much a subculture as a way of life.

# Artist development

Successful artists are those that stand out from the crowd. Their work may be noticed because of the quality of their style, the quantity of the work they complete, the high profile of the works' location and position, or a combination of all three.

Each artist spends countless hours perfecting and refining their style. This style will clearly identify the creator. The eyes of Aryze's and Prism's characters, seen throughout this book, are perfect examples. Aryze's characters have large eyes with a couple glints of light; Prsim's have larger eyes that are devoid of expression.

Masterpieces come only with patient development of skills, techniques and an appreciation for the available paints and canvases. Novices are referred to as 'toys' by more experienced writers, while the most experienced artists are referred to as 'kings' if their work is deemed worthy of respect. It takes years to become a 'king'.

If artists are driven to get their work seen, choosing the right spot counts for a lot. A "No War" slogan was painted on the roof sails of the Sydney Opera House in 2003 – that's as high profile as it gets.

But a high-profile location will not be worth securing if the quality of the work is so bad that someone immediately goes over the work or, worse, tags it as having been created by a 'toy'.

There is a two-way relationship between street art and other visual forms of popular culture, such as graphic design, comics and advertising. Street art saturates our media – it's in the news and used in advertising. By the same token, street art is inspired by design in the broader world, and may make use of images taken from the mass media.

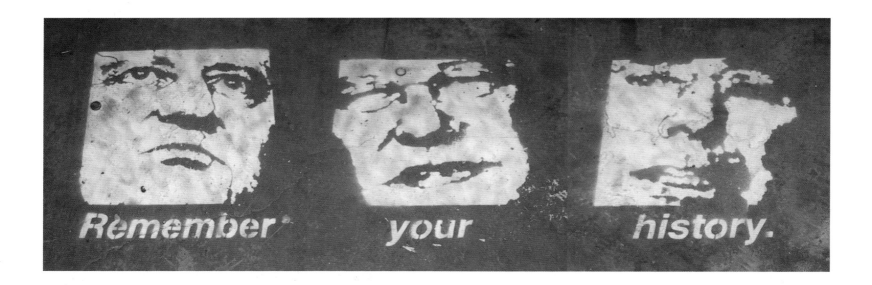

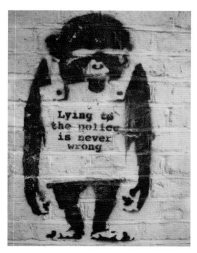 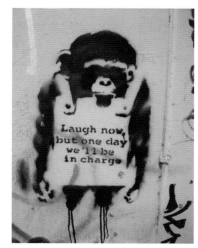 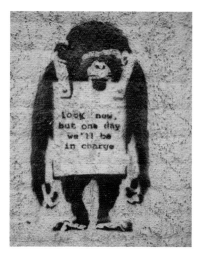 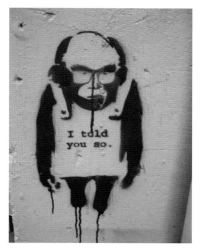

These four pictures show the classic evolution of a stencil. The original artist probably had no inkling of how the stencil would eventually be used. The final stencil is an image of John Howard, the Australian Prime Minister at the time of the invasion of Iraq. The imagery is quite apt.

# Divergent evolution

Street art is constantly evolving. Since 2000, Melbourne has seen a phenomenal expansion and development of graffiti, with new ideas and new techniques emerging. Stencils have boomed, along with posters and stickers, plaques and mosaics.

Street art concepts can now spread via the internet. Websites with online image libraries containing work from all over the world abound. New trends can be picked up from one country and instituted in another (the John Howard monkey above is a good example).

By looking at a large collection of street art created in Melbourne over the last five years, as this book does, it is possible to gain not only an insight into the breadth and depth of street art in a single location over a fixed period of time, but also into the patterns that emerge.

The development of street art accords with many of the principles of Darwin's theory of evolution. Graffiti evolves microscopically for a while and then in leaps and bounds, before slowing down again. It develops both out of a single point and towards a single point, mimicking divergent and convergent evolution as it jumps between genres.

For example, stencils were in vogue between 2002 and 2004, interrupted by a flourishing of plaques which quickly perished. The current trend is towards stickers and paste-ups. Now, too, many of the artists who started out in these forms have moved into 'graffiti proper', spray can art on railway lines as large, colourful pieces.

Where the trends take us next is anyone's guess.

"The work evolves, and the artist will tend to take an evolutionary direction. It is interesting to follow the constant development process – it is totally different from an exhibition, which is static. The graffitists' ideas always change, and the canvas always changes" – Soniarella, Melbourne street artist.

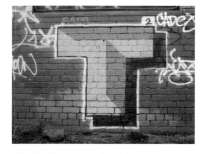 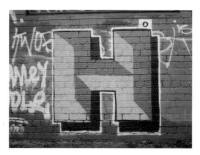 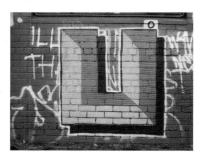 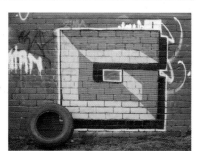

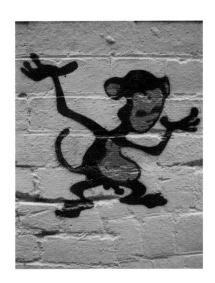

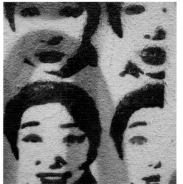

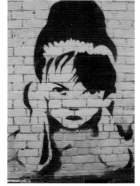

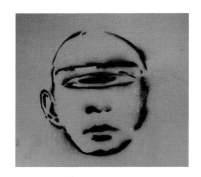

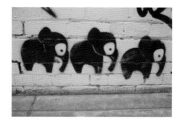
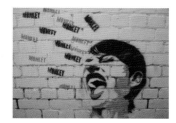
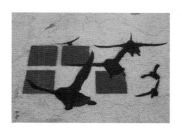

# Stencils and stuckistry

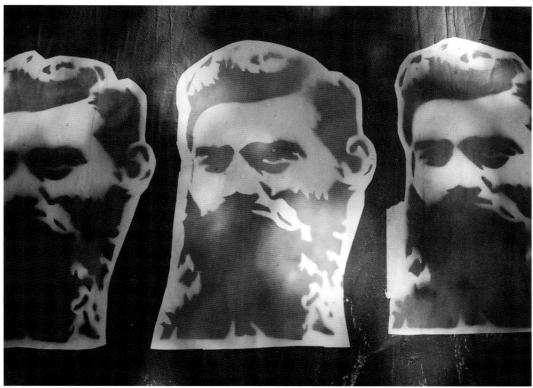

Of all forms of street art, stuckistry has arguably seen the greatest development over the last four or so years.

Stuckistry has people talking, has been covered in local and national newspapers, and has been featured at festivals, the Melbourne Grand Prix and other major events.

There have been innumerable exhibitions in all major cities. Melbourne has had visits from internationally renowned stuckists, and has its own home-grown talents. There are regular exhibitions in Melbourne, at places such as Shed 14 and city galleries like the Fad Gallery, as well as at the Stencil Festival.

Melbourne City Council is even considering legalising the use of stuckistry in some laneways, at least in part because the council recognises that street art can attract tourists.

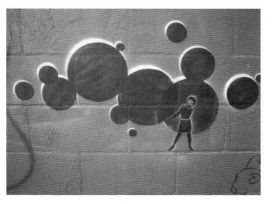

**"Street art is OK in public spaces that are rundown and not looked after. The street artists are reclaiming that public space for the public" – John, IT technician.**

# Politricks

'Politricks' is a term I once saw used in some Melbourne graffiti, and I think it perfectly encapsulates the current state of foreign and domestic politics. The present Australian government provides plenty of material to inspire the politically aware graffiti artist. A perfect example is the picture above of poppies behind barbed wire, presumably a reference to Afghan refugees and detention centres. But Australians tend to be apathetic about politics, and so political graffiti is rare in Melbourne. Perhaps this is because of Australia's comparatively high standard of living. From my perspective as a migrant, Australians seem to have a generally uncomplicated view of life and the world – summed up by the "she'll be right" attitude – which might be another reason for the lack of political graffiti.

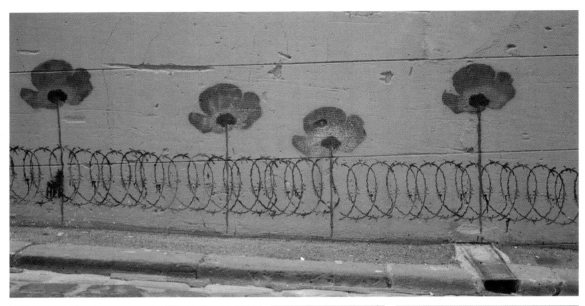

**Meek's 'Keep your coins, I want change' has evolved several times, with the latest variant – 'I want Reks' – appearing early in 2004. This is actually a bastardisation of the original by another artist.**

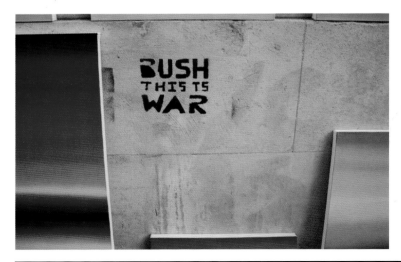

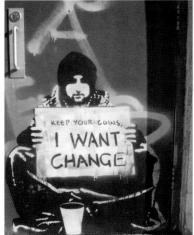

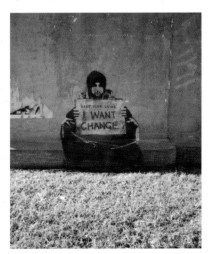

20

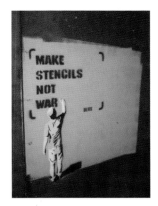

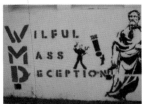

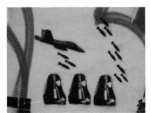

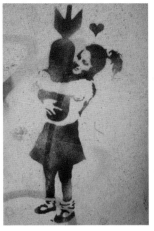

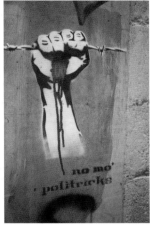

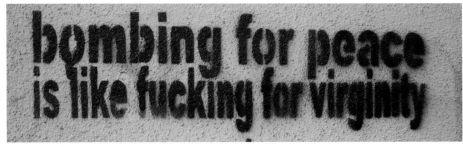

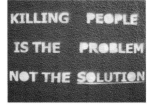

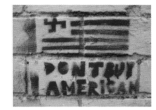

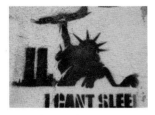

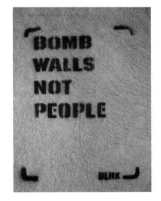

# Is the message clear enough?

Political graffiti is, almost by definition, about expressing dissatisfaction and raising awareness. While the details of who and what the graffiti is about vary with changes of government and the emergence of new issues, the general thrust of political graffiti remains constant.

But in recent years, there has been a change in the medium preferred for expressing political graffiti: stencilling has all but replaced the use of paint and texta that was prevalent in the 1960s, '70s, and '80s. As well, the use of images in political graffiti has become increasingly complex. The creative expression in the graffiti shown above makes the political message more poignant.

Meek's love heart bombs falling from a plane and Satta's hand clutching onto barbed wire to represent government policies on detention centres illustrate how signs and symbols are used in stuckistry.

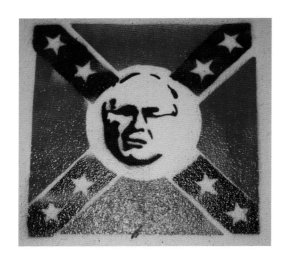

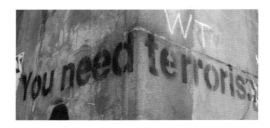

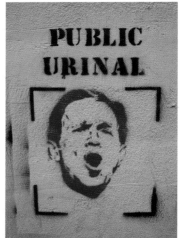

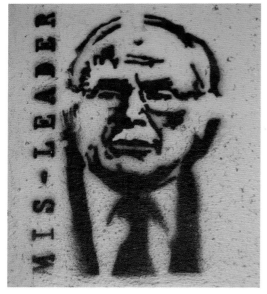

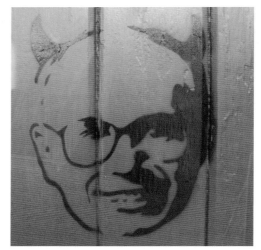

**Spot the terrorist?**

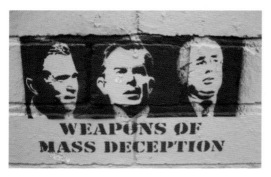

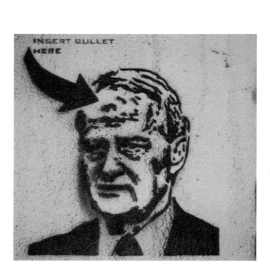

# The unedited text of the people

Political graffiti is unedited and, at least until it is removed, uncensored. It is intended to be confrontational; it doesn't aim to please. Unlike the mass media, which increasingly toes the government line and has certain expectations of its contributors, street art allows writers to express their thoughts freely. Such freedom allows great potential for creativity. This kind of communication might not always be aesthetically or politically pleasing to every viewer, but it is thought provoking. In fact, political graffiti can reflect the audience's attitudes more closely than the mass media.

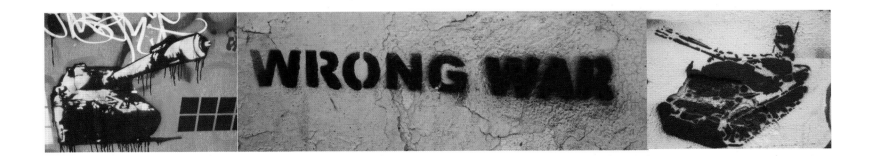

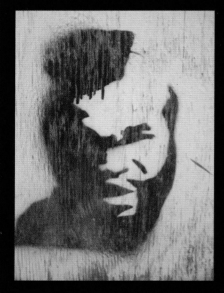
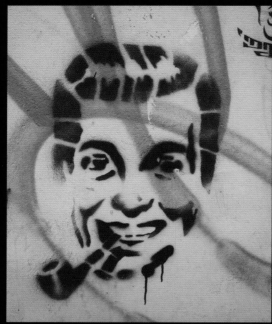
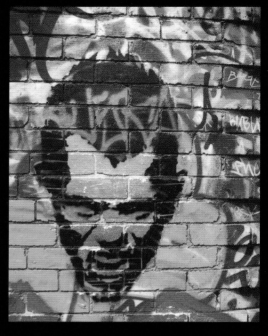

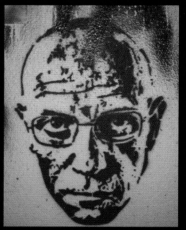

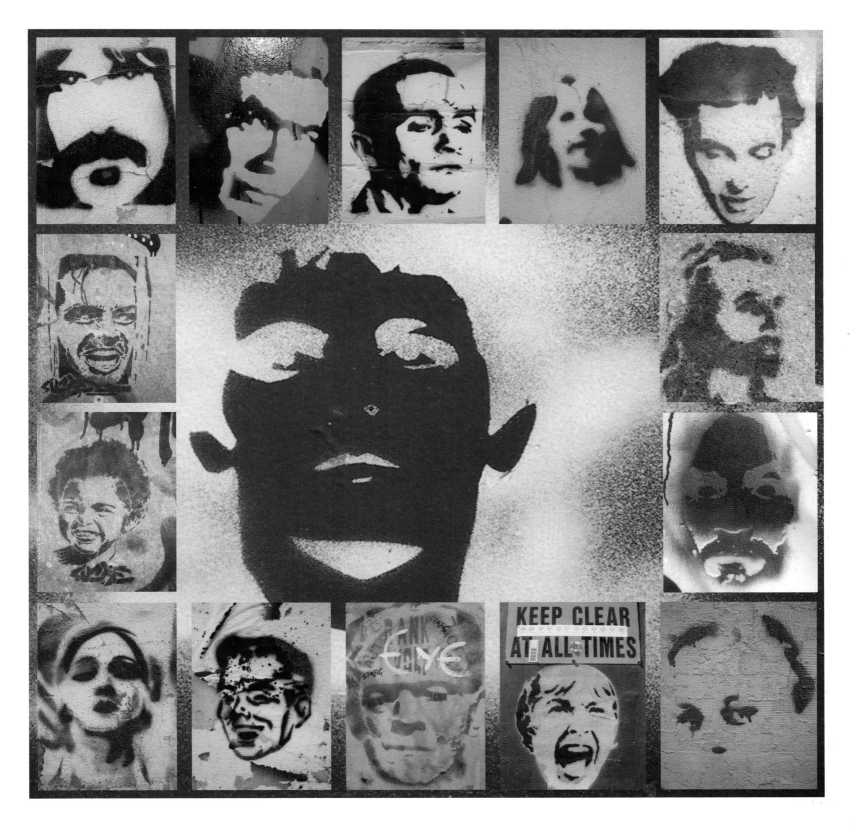

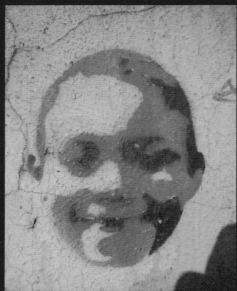

# Stencilling techniques

Stencilling is not as straightforward as it might first appear. It is painting through a cut out shape, but that shape must be prepared.

Stuckists must either find or create a design for their stencil. Images often come from photos available on the internet. I have seen stencils featuring stars from both adult entertainment and Hollywood movies, as well as politicians, cartoon characters, and many other recognisable icons. Electronic images are simplified on the computer using an appropriate software package to make them less complex, and therefore suitable to the requirements of stuckistry. Hand-drawn images must be designed with those requirements in mind.

After the image is modified, the final step is to cut out the areas of the image which will be painted. Stencils can be cut out by hand or by a professional sign cutter using vector files. If two identical images have the opposite pieces cut out, the effect is of a photo and its photonegative.

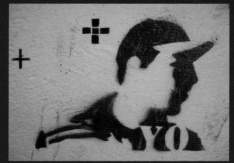

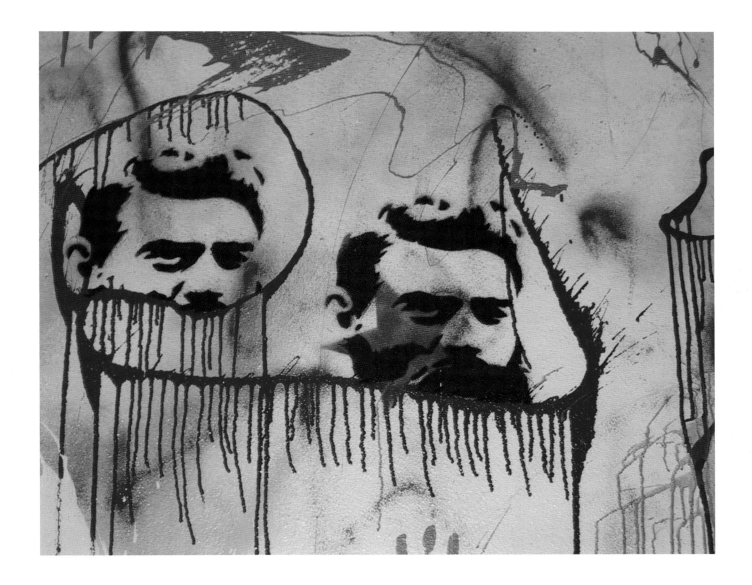

**Ned Kelly is an Aussie folk hero. He is often portrayed as the Australian version of Robin Hood, robbing the rich and giving to the poor. As an instantly recognisable icon of Australian culture, his image is an ideal choice to be represented through stencils.**

"Any publicity is good. As an artist I love to see people noticing my work. I discovered one of my pieces on the web recently. It is great to see people photographing it" – Melbourne street artist.

# Noah's Ark - the came two by two and even more

From time immemorial, humans have represented the shapes and patterns of animals in their art. Because animals are so easily recognisable, they lend themselves well to stencilling. Animals featured in stencils are often depicted unimaginatively. Recognisable shapes are iconic, and therefore can be simplified and modified, allowing the artist greater creativity. The artist at the top left has taken this next step; the three elephants are hugely appealing, with simplified silhouettes and large eyes. Images such as faces, robots and planes are also easily recognisable and therefore heavily used by stuckists.

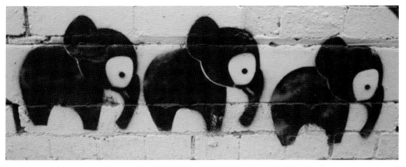

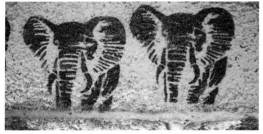

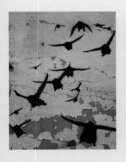
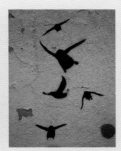

## Air and water

Civil, whose work is displayed on this page, typically follows one of several personal styles. The only element regularly incorporated in his work is the use of blocks as shown on the bottom left.

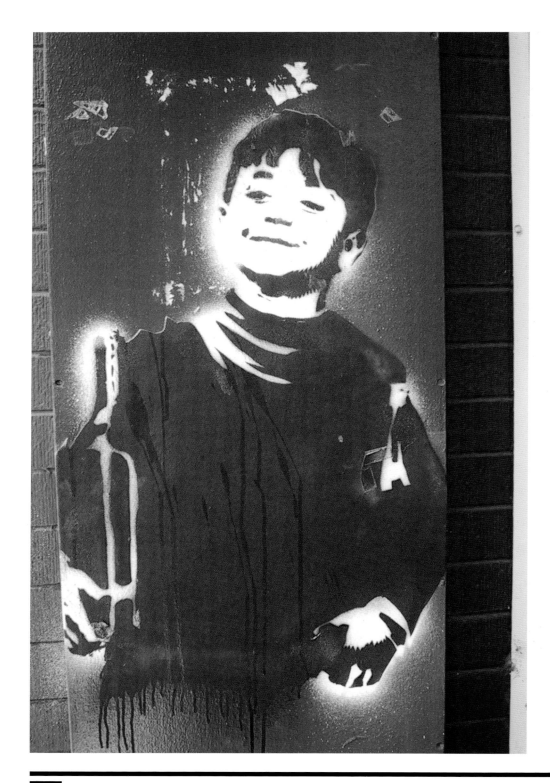

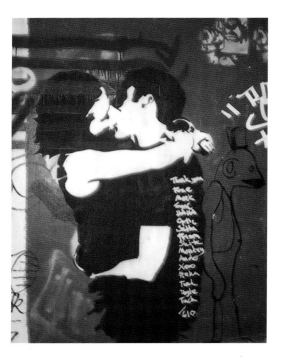

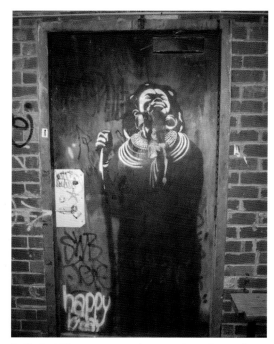

Satta's African woman is one of my favourites.

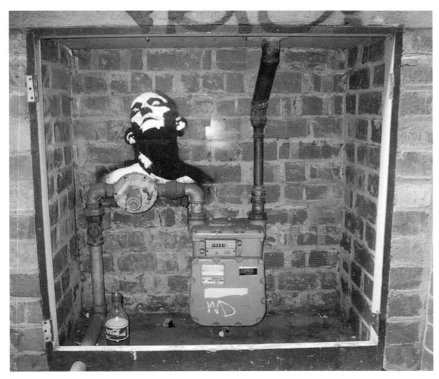

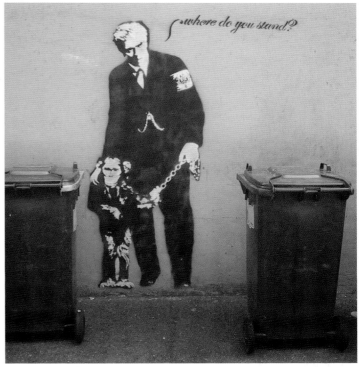

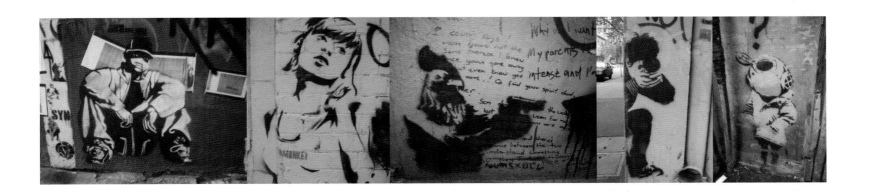

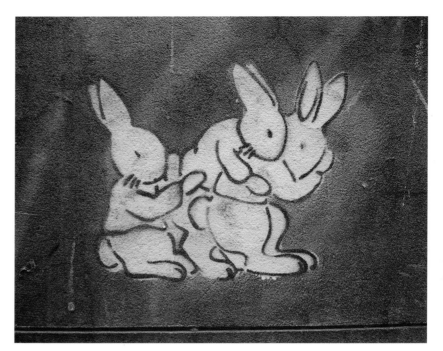

These stencils provide an insight to the artist through the source of the materials that they have elected to use. It is likely that all of these images have been gathered from the Internet rather than the artist having individually created them. These then will often form the baseline character for personalisation by the artist using their unique characteristics or trademark style.

Aryze's characters, for example, will always uses large moonlike eyes, while Prism uses staring or blank dead eyes. Clockwise from top left, we have a character from the computer game Grand Theft Auto, a Beatrix Potter-like shagging rabbits logo (courtesy of humorous stencil artist), a 90's porn star, Porky Pig and an Aussie icon export, Rolf Harris.

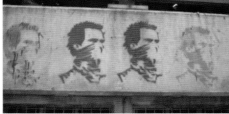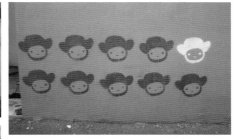

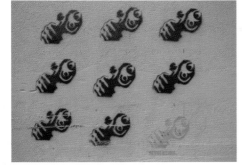

# A kind of fame - street art in the eye of the curators

Street art has exploded so prolifically that the National Gallery of Victoria in Melbourne has made a point of watching the scene and tracking recent developments, most notably in stencilling. The gallery has even gone as far as saying that it is the equivalent of the political posters of the 1970s and '80s that dealt with a range of contemporary issues.

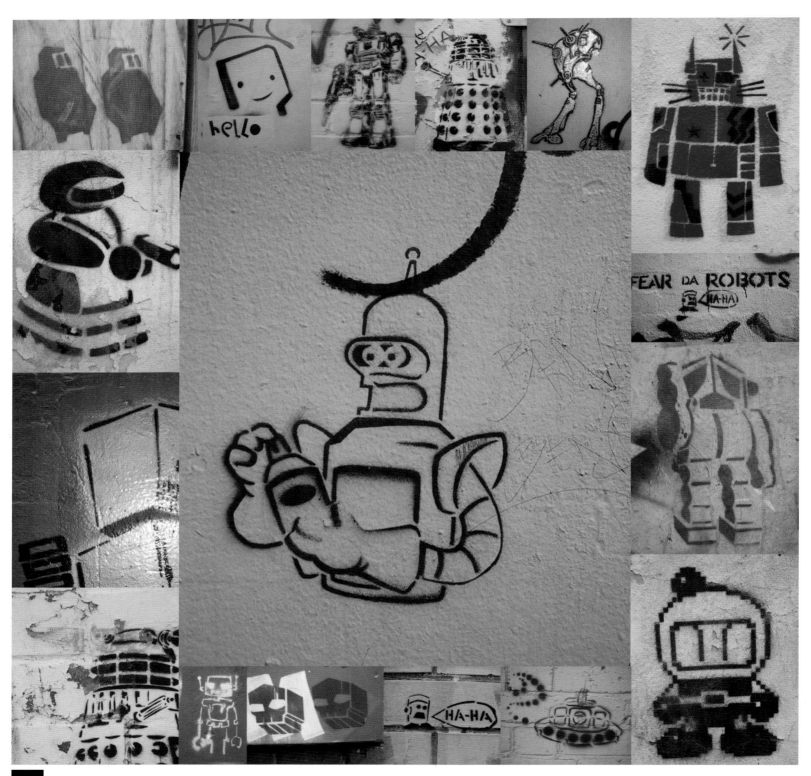

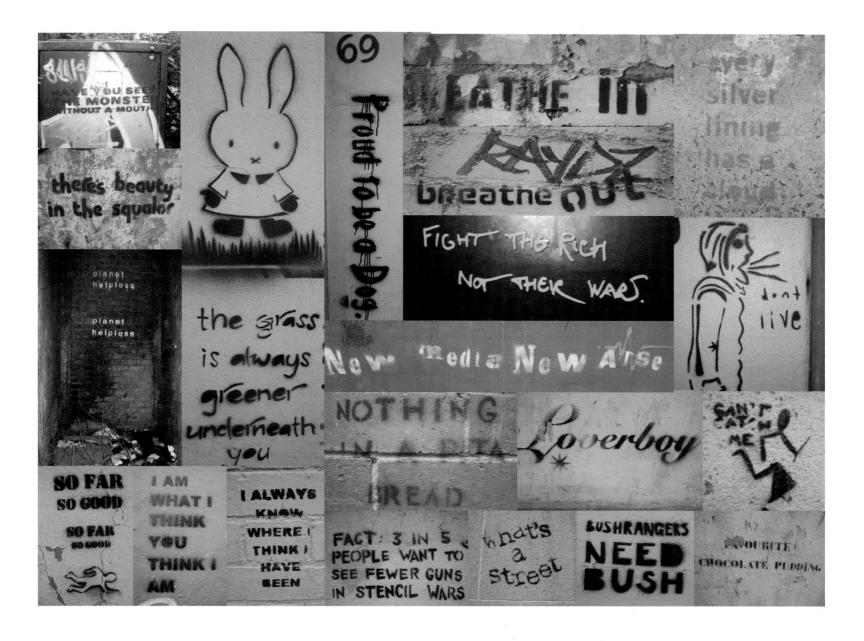

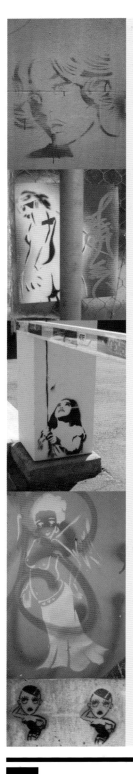

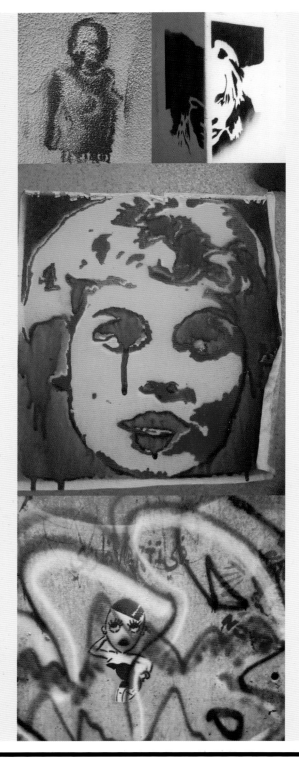

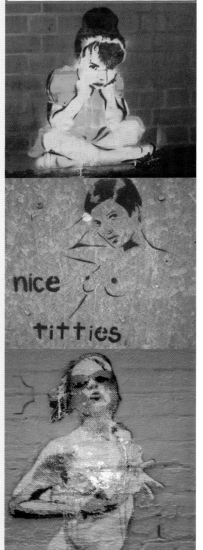

This little girl can be found beneath a bridge which is frequently flooded. As a consequence she often disappears beneath the waters and then rises again phoenix-like as the waters subside. She is like a mini rain gauge. Caged under a noisy bridge out of the sun, and often drowning, she looks like she is sulking for eternity, and you can understand why. Today she is just slowly moulding away.

nice titties

These examples of abstract street art show the importance of the background surface to the image. The texture of the environment is captured where it might otherwise go unnoticed. Artists and writers alike can benefit or be undone by the texture of the surface they choose to paint on. Some surfaces soak up too much paint, others cause the paint to drip more readily.

No matter what surface is chosen, a wooden fence, a brick wall, or a gravel surface, for example, its texture will influence the artistic effect. Pebble-dashed walls have a particularly striking three-dimensional impact on a piece, but require significantly more paint. To allow for these variations artists need to develop an understanding of the surfaces upon which they write.

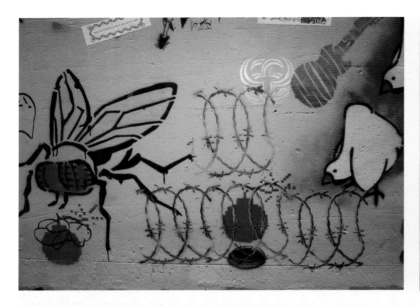

"Some people are looking for fame, some people want to make a difference and see this as a way of getting a message across, some people think that public property is truly 'public property' and thus they can do what they want to it, some people just like causing chaos" – Sam, banker.

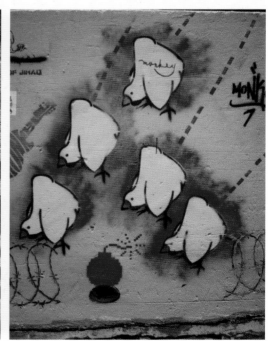

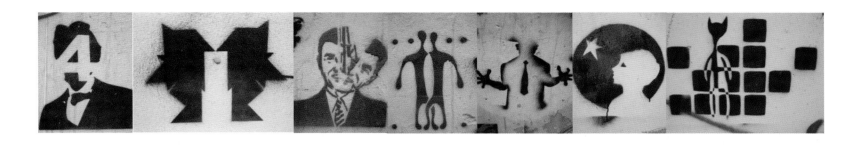

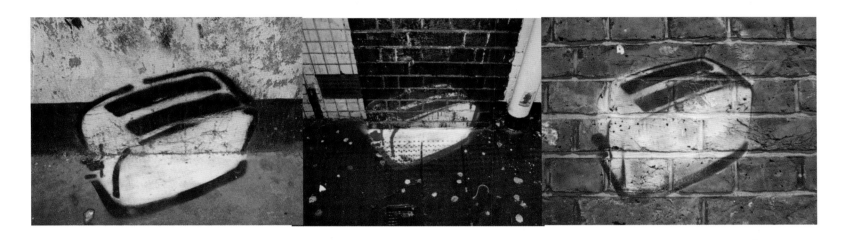

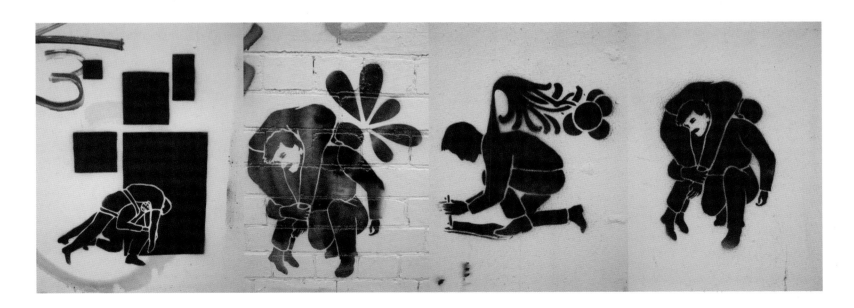

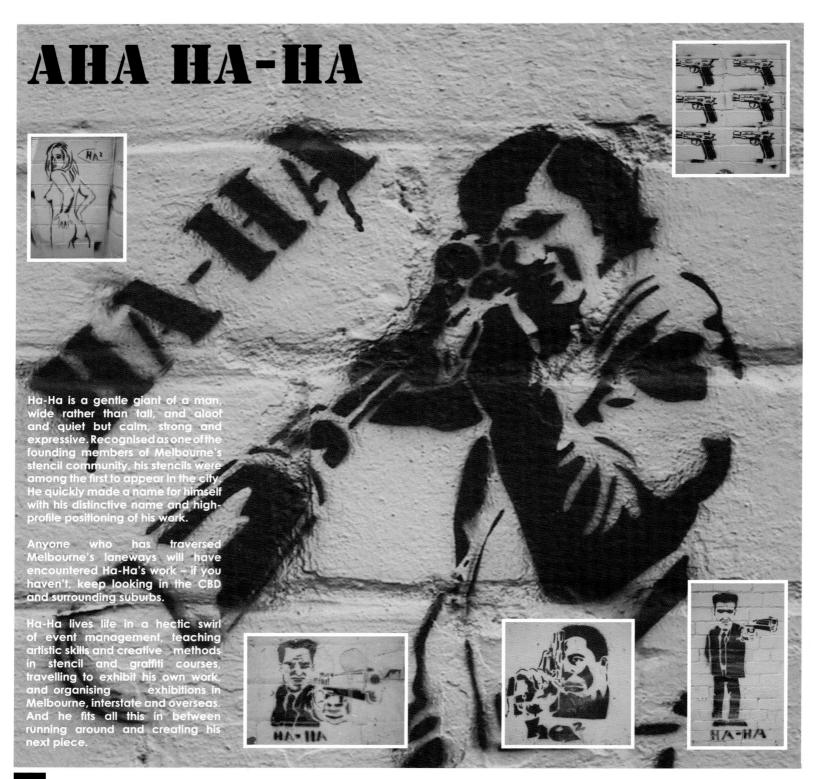

# AHA HA-HA

Ha-Ha is a gentle giant of a man, wide rather than tall, and aloof and quiet but calm, strong and expressive. Recognised as one of the founding members of Melbourne's stencil community, his stencils were among the first to appear in the city. He quickly made a name for himself with his distinctive name and high-profile positioning of his work.

Anyone who has traversed Melbourne's laneways will have encountered Ha-Ha's work – if you haven't, keep looking in the CBD and surrounding suburbs.

Ha-Ha lives life in a hectic swirl of event management, teaching artistic skills and creative methods in stencil and graffiti courses, travelling to exhibit his own work, and organising exhibitions in Melbourne, interstate and overseas. And he fits all this in between running around and creating his next piece.

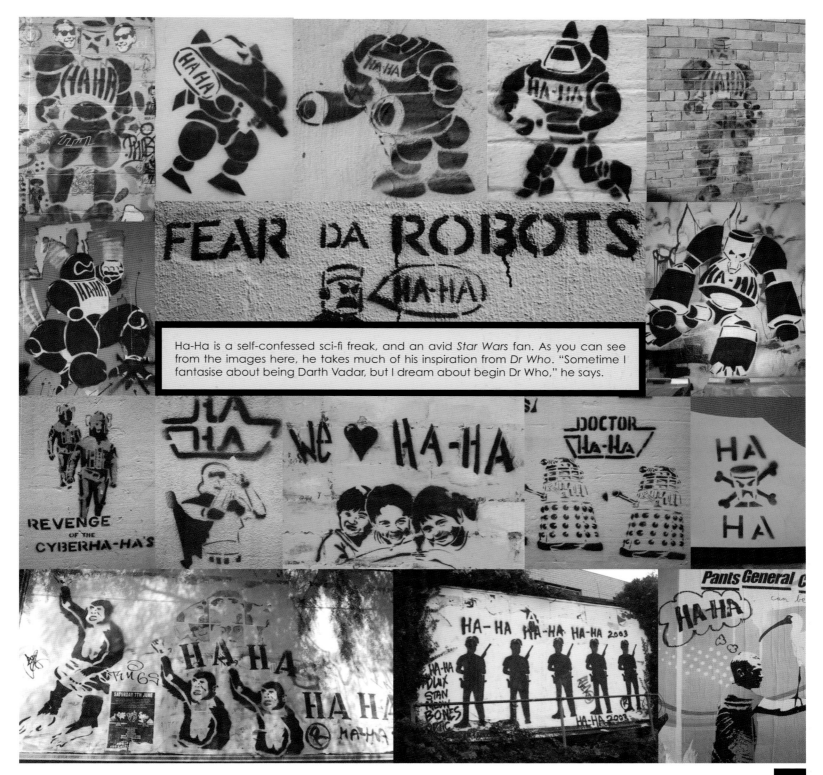

Ha-Ha is a self-confessed sci-fi freak, and an avid *Star Wars* fan. As you can see from the images here, he takes much of his inspiration from *Dr Who*. "Sometime I fantasise about being Darth Vadar, but I dream about begin Dr Who," he says.

# DLuX

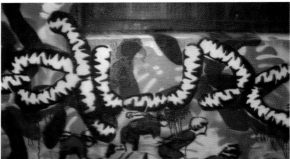

DLuX was brought up in the country, and then moved to Adelaide before following in the footsteps of many of that city's street artists by relocating to Melbourne. He was inspired by Sync, an artist who specialised in stickers and posters at the time. Sync's work is featured later in this book, and I think its quality shows why DLux was inspired to compete as an artist and develop his own inimitable style – the work of the two artists are completely different. DLuX's use of his tag to create footprints on his drunken walk, featured on page three, is my favourite of his works.

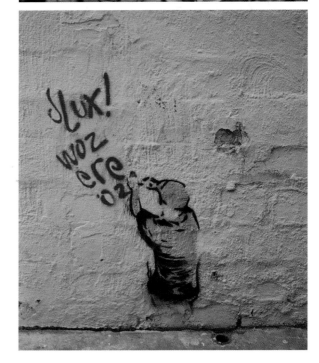

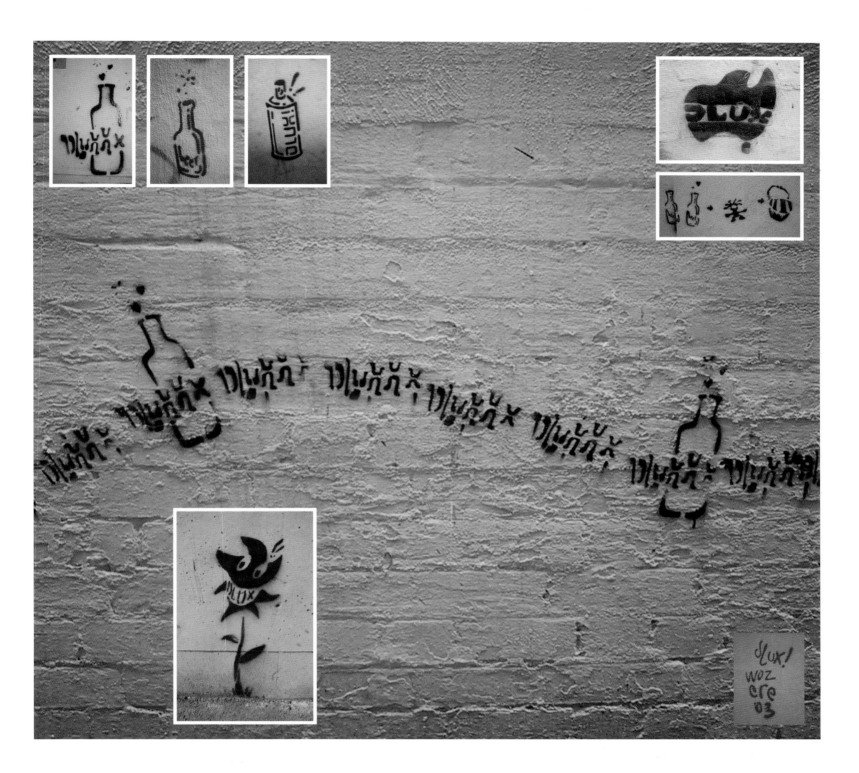

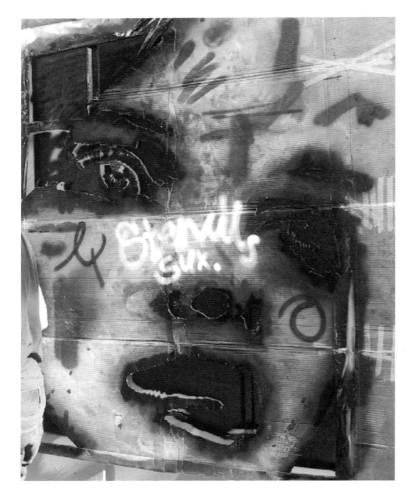

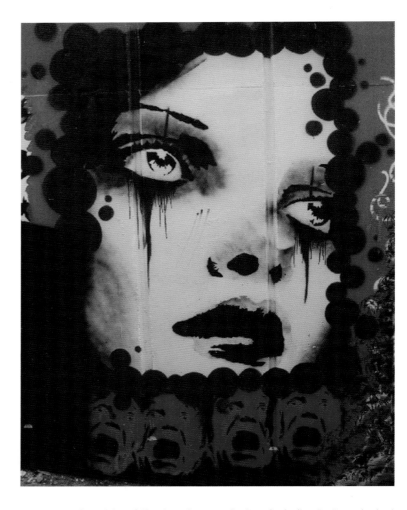

# Rone's faces before and after

The style of the two images below is similar to Rone's, but they were actually created by Monkey.

Rone, originally from country Victoria, is a relatively new but well-respected member of the Melbourne stencil and graffiti scene. His works are often large and spectacular. Inspired by New York street artist Shepard Fairey's Giant, Rone has developed a signature style of strong facial silhouettes. They almost always show the right side of the face, although Rone says there is no particular reason for this.

The work shown above was created for the City of Port Phillip free-for-all at St Kilda Junction. The photograph on the left was taken at the start of the stencilling process; when it was created using cardboard taped to a wall painted yellow for the background. Phibs added the friendly graff-stuckist banter "stencils sux". The photograph on the right captures the final product, which shows great use of placement and the subtle addition of drips and shading. These elements can make or break a piece of street art in terms of quality, and therefore the respect it is accorded by other artists.

These stencils were produced by students in the Industrial Design course at RMIT university, under the auspices of the institution. Many people engaged in graffiti have studied art at school or college.

# Vexta's leaves

Vexta's stencils of leaf–hands are almost surrealist in nature. The hands of older people become increasingly wrinkly, paper-like and veiny, like these old deadened leaves falling in the autumn breeze. The effect is softened by the paint splats over which the leaves were stencilled. Splats and spots of paint were in vogue during 2004.

Civil has a number of distinctive styles. In this example, he has cut-out as much of the image as possible and sprayed through with just a single colour. It is visually striking and elegant in its simplicity.

I initially thought the bottom image was a modern-day version of knights from the Middle Ages. In fact, it represents the disgruntled employees of a cycle courier firm. One of those couriers, who is a courier by day and street artist by night, told me that after a management shake-up, many of the couriers had resigned. All of them contributed in some way to this epitaph on a city wall.

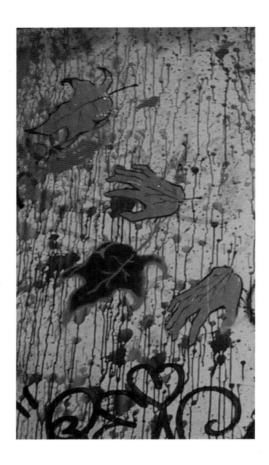

The series pictured above shows stencilled paving slabs in a busy café and shopping arcade.

The images below can be found on the concrete wall slabs that form the exterior wall of a car park.

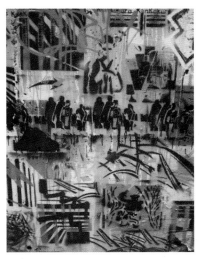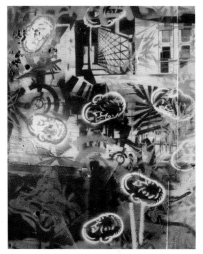

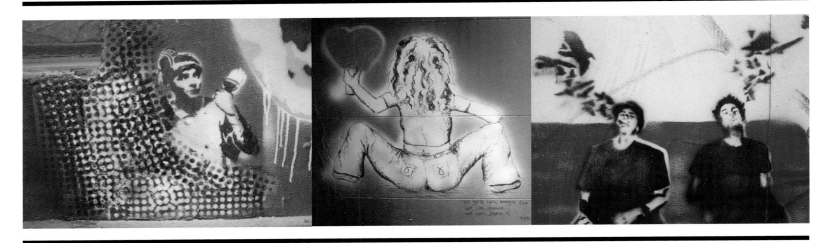

The dots on the image above were added by the artist to cover over a mistake. The image is all the better for the correction to the error.

# Colours and multi-layering

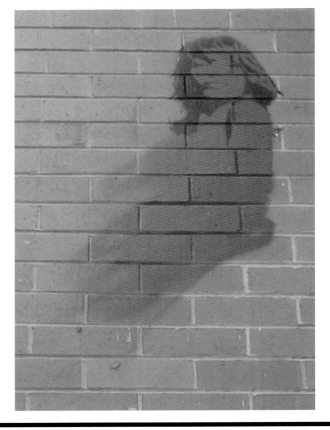

These stencils illustrate the complexity that can be achieved through the use of several colours and multi-layering, where several stencils are created in order to achieve the final effect. Working with multiple stencils can be confusing: if the artist gets them in the wrong order, the whole image is out of whack. Given that the artist is working under time constraints because of the risk of being caught, the pressure to get it right the first time is high. The trick, of course, as Rone would put it, is to look as if you own the joint and not to spend too much time looking over your shoulder.

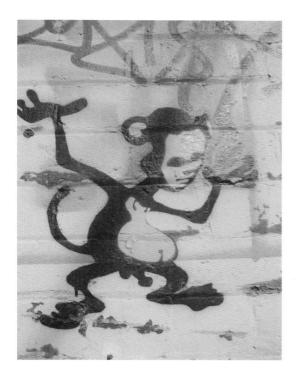

# Monkey bites

Given that we are pre-programmed to recognise the human face and form, and that primates are human-like, it is not surprising to find that monkeys are one of the most common street art icons. They are easy to simplify and caricature, lending themselves more readily to the technique of stencilling.

Monkeys, the cool cats of street art, are fun, colourful and playful, mimicking our lives. These two designs have been much admired on stencil websites. The bottom design was created for t-shirts by, appropriately, Monkey.

**Long live our monkey madness.**

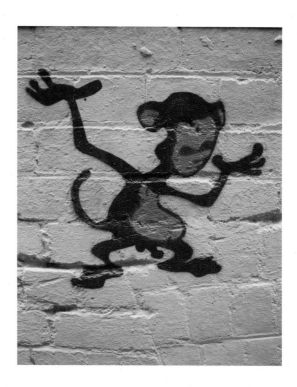

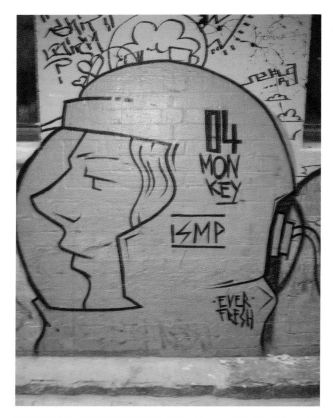

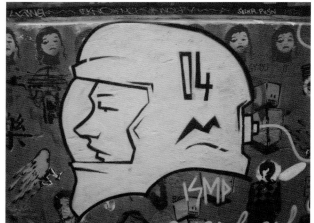

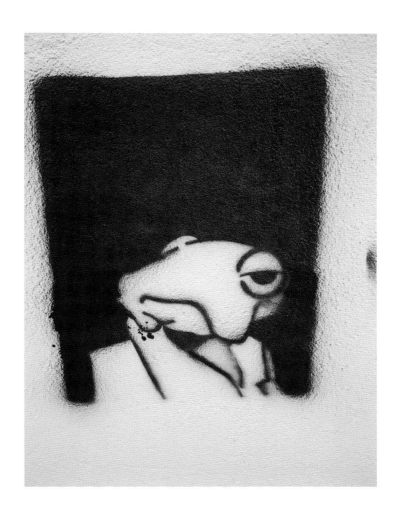

# The guardians renew an ancient tradition

There is something quietly satisfying about having these characters protecting the entrance to an office block in Northcote. One was painted on each side of the office at the foot of the steps to the entrance. It is as if they are challenging someone to enter unnoticed.

It is a modern, tongue-in-cheek renewal of ancient traditions, reminiscent of the use of statues to guard old buildings and cities and the lions protecting the main gateways into the City of London or the gargoyles protecting Europe's old churches.

These guardians made me laugh, both at the concept, and the audacity of the artist.

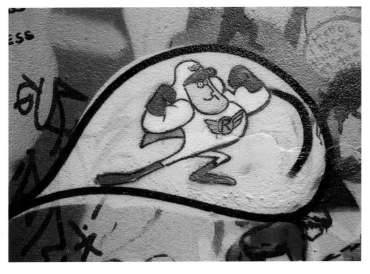
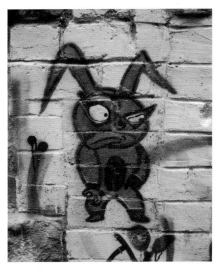
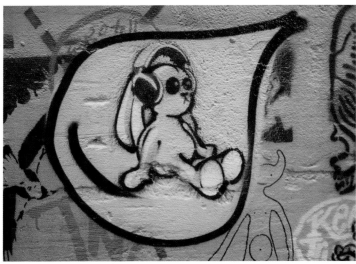
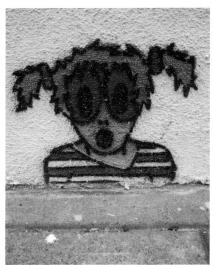

# Plaques

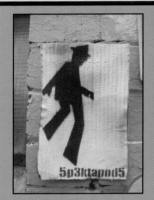

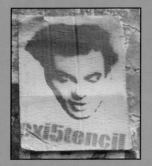

Stencilled plaques made a brief appearance in Melbourne when stuckistry was the dominant trend, but started to disappear when paste-ups and stickers became increasingly popular. There were probably a couple of reasons for their emergence. First, they differentiated the street art specialist from the ordinary scribbler. Second, because sticking things on walls is regarded less seriously by the law than painting directly onto the surface, plaques, like paste-ups and stickers (see page 55), are a safer form of street art.

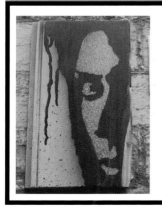
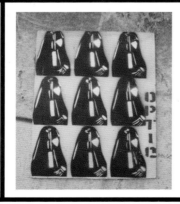
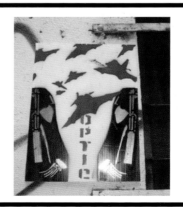

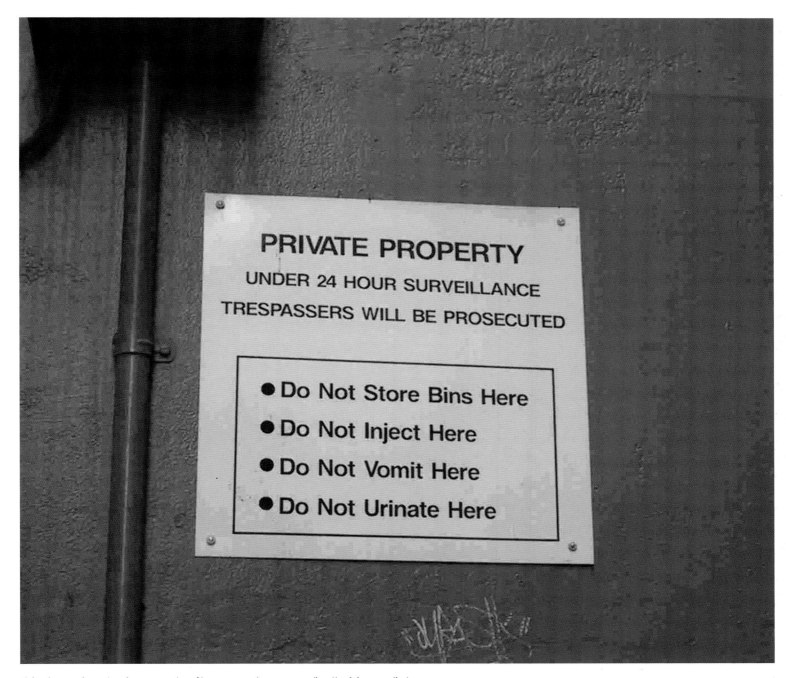

**PRIVATE PROPERTY**

UNDER 24 HOUR SURVEILLANCE

TRESPASSERS WILL BE PROSECUTED

- Do Not Store Bins Here
- Do Not Inject Here
- Do Not Vomit Here
- Do Not Urinate Here

This plaque is a classic example of how people personalise their immediate environment. It was outside Melbourne CBD's smallest apartment.

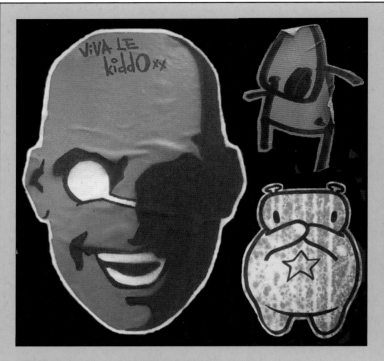

A classic poster that I found just metres from my home. I read this as being symbolic of the modern cross we have to bear: corporate greed and globalisation.

# Sticking it 2 the city

Stickers and paste-ups are graffiti, even if they don't fall under the strict definition of the word. They are marks, and they are applied to the wall, but the marks are made on paper which is then stuck to another surface. In one way, stickers and paste-ups could be seen as an exercise in risk reduction, given that the penalties for putting up paste-ups and stickers are less severe than those for spray paint or texta graffiti, and that the ease and speed of putting them up makes it less likely that the offender will be caught in the act. But stickers and paste-ups have other advantages too: they can be mass produced and therefore distributed in large quantities and cheaply; they can be created off-site; and they can be a particularly effective form of 'branding' for the artist. I find myself drawn further and further into this public but hidden world.

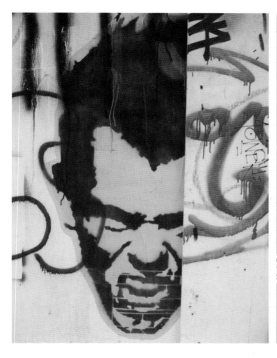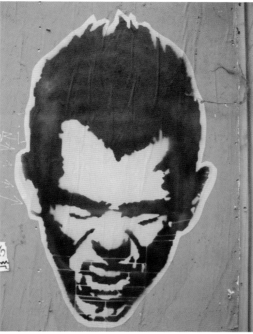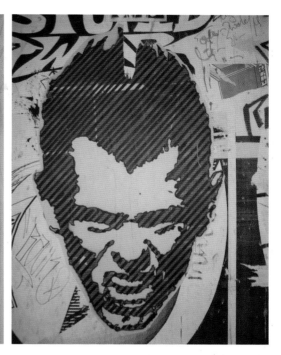

# Replication and mutation

Graffiti lends itself to the kind of transmission of images that is sometimes described as 'memetic'. A meme can be most broadly defined as a piece of information that is passed between people. Like a gene or a virus, it both replicates and mutates during this transmission.

A number of forms of street art lend themselves particularly well to memetic transmission, most especially, stickers, paste-ups and stencils. The graphics can easily be posted on the web, and so shared between peers across international boundaries.

Street art derived from images that became commonly used memes exploded in Melbourne after 2000. Posters, stickers and cut-outs were made from paper, card, and even polystyrene (see Psalm between South Yarra and Richmond), in fact anything light and easy to print on.

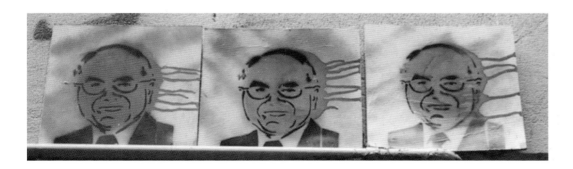

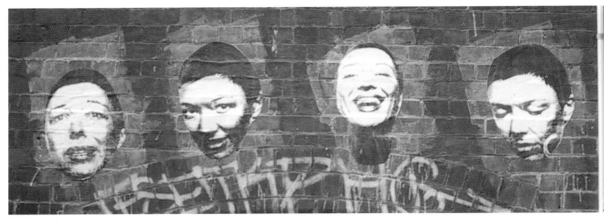

# Collecting the ephemeral

Unlike graffiti that is painted straight onto a wall, stickers and paste-ups can be collected by aficionados. Artists report spotting their own stickers on other people's guitar cases and luggage, and even seeing them peeled off at the source, or. Depending on the surface, though, the collector can find it difficult to remove the stickers without damaging them, unless they've been stuck up very recently.

Given that most stickers and paste-ups are placed outdoors, the collector must also contend with the effects of the weather. Paper gets soggy, cardboard expands with rain, and sunlight bleaches both. Savvy creators know that paper stickers are best used indoors and under cover, while vinyl or some other plastic-based material used with weatherproof ink can survive outside.

Like paint-based graffiti, paste-ups and stickers last only as long as the tolerance and maintenance cycles of the local council permits. While the penalty for stickers may be softer, they can actually be more difficult to remove. Paint or texta-based graffiti can be removed with solvent-based cleaners; removing stickers requires attacking the adhesive and scraping off the paper or plastic.

An artist will only see an accumulation of their art if they can counter the effects of weather and stay a step ahead of councils' cleaning technology.

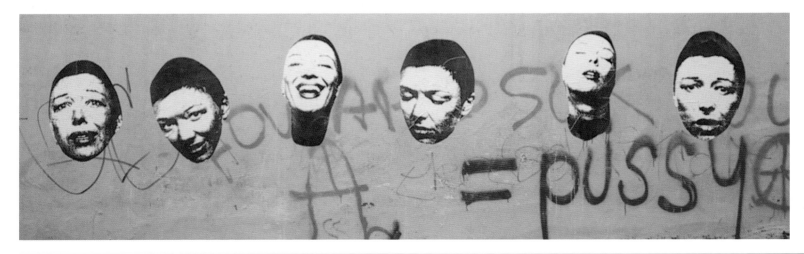

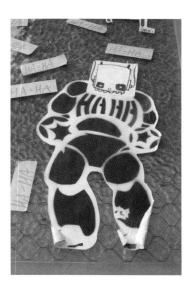
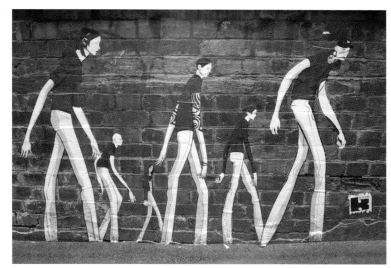
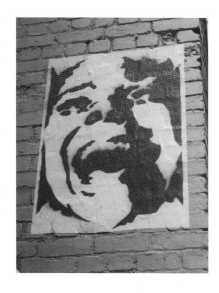

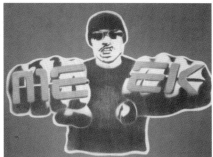

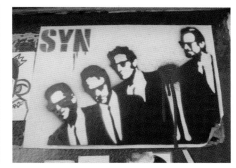

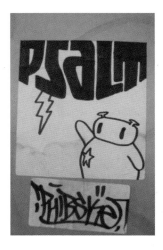
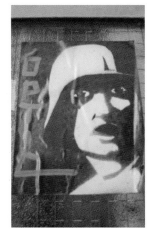

## The factory line - sticker production

Artists may hand draw their images onto stickers or paste-ups (Phibs, Aryze and Reka, for example, often do this), or they may mass produce them, usually electronically.

If the image is to be mass-produced, hundreds of copies will be pasted up. If the design is respected by others, it will be posted online, and may begin appearing elsewhere around the world.

Purists draw images onto individual stickers, but few artists are able to maintain this level of dedication. At some stage, it is likely that a design will be mass-produced. Block-shaped stickers can be cut using a guillotine, but the creator's patient hands may have to carefully cut out irregular shapes.

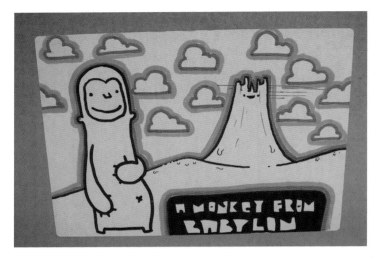

# Peelable and portable

Stickers tend to be smaller than most stencils, tags and pieces, and this influences their design and placement.

For larger pieces of graffiti, the lack of spatial constraints means that design is less important, and style takes precedence. But with little space within which to work, the sticker artist must create a strong, punchy design, ensuring that the image is both recognisable and memorable. This strengthens the artist's assertion of their identity and makes the sticker desirable to collectors.

So it is a mixed blessing that because smaller images need to be placed at eye level to be noticed, they are therefore more easily removed than larger images, which, because they are more likely to be noticed by virtue of their size, can be placed in harder to reach places.

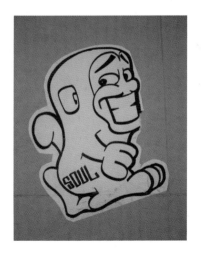

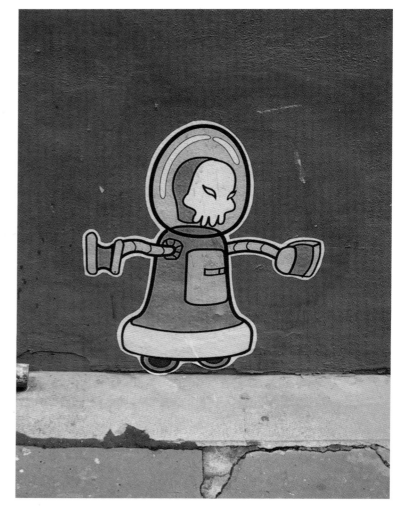

The content of stickers varies, but sticker artists tend to specialise in characters and distinctive drawing styles. A consistent style is a must if an artist is to differentiate their work from others', a key objective in street art.

This differentiation could be seen as a form of 'branding', with sticker artists using their work to market themselves and their work. Many artists have created an identity through their mass-distributed stickers, as they are an effective means of distributing an artist's tag and brand of street art. Often stickers will include a tag name, or sometimes contact details for the creator, usually an email address. This enables artists to network with likeminded people.

Stickers develop into a portfolio of work, a portfolio that exists both in the traditional sense and on the street.

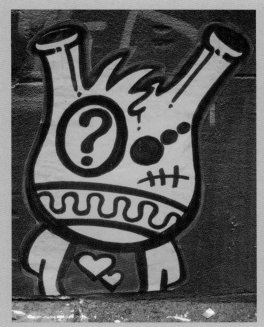
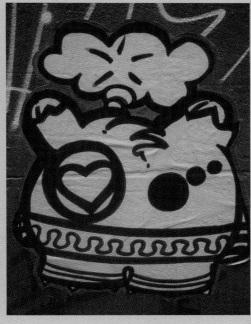
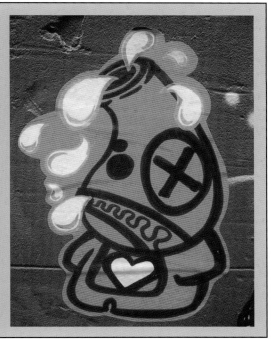

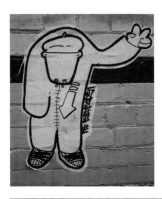

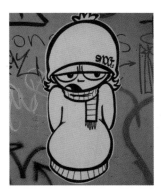

While tags and pieces are exclusive to street artists, stickers are not. They are used in many contexts, so it can be harder for authorities to detect the illegal variety. This is especially the case when artists deliberately base their designs on official or commercial stickers to avoid detection and subsequent removal. A particular form of this, subvertising, is discussed later in the book.

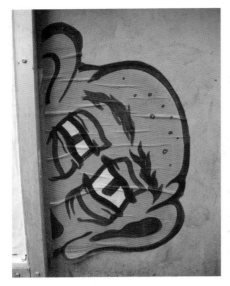

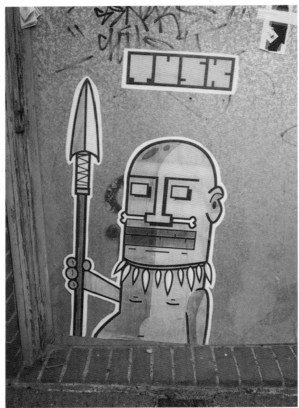

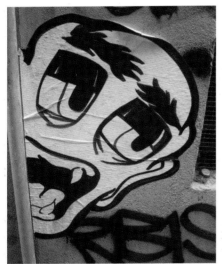

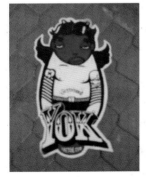

Yok's character, as shown in the two images at bottom left, is often found without a chin. The intent is to encourage passers-by to get involved by adding to the image. Many of Yok's chinless wonders have wound up with increasingly elaborate beards and chin decorations. This approach has helped establish a cultish respect for Yok and his characters, ensuring an ongoing following amongst both street artists and the general public.

# Elizabeth Street Ghosts

Phib's ghosts began to appear on Elizabeth Street in Melbourne's city centre in early 2003. These were the first paste-ups I saw attracting the attention of passers-by. The brazen positioning of them at one of the busiest junctions in the city, on the corner of La Trobe and Elizabeth Streets, meant that they got plenty of attention. Unfortunately they are now removed as quickly as they arrive.

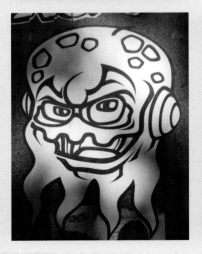

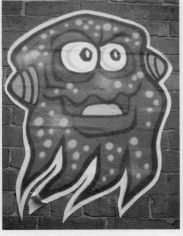

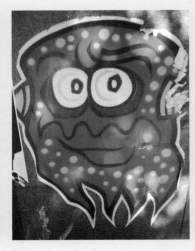

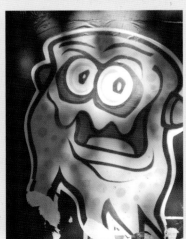

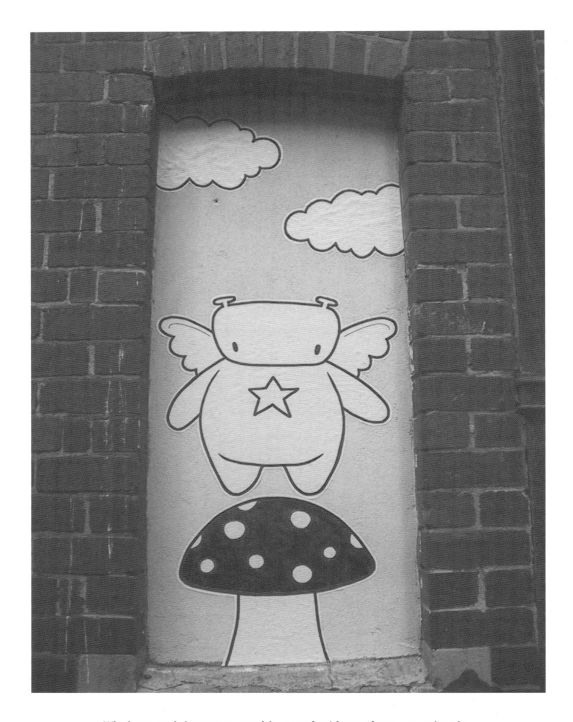

Windows and doorways provide a perfect frame for many artworks.

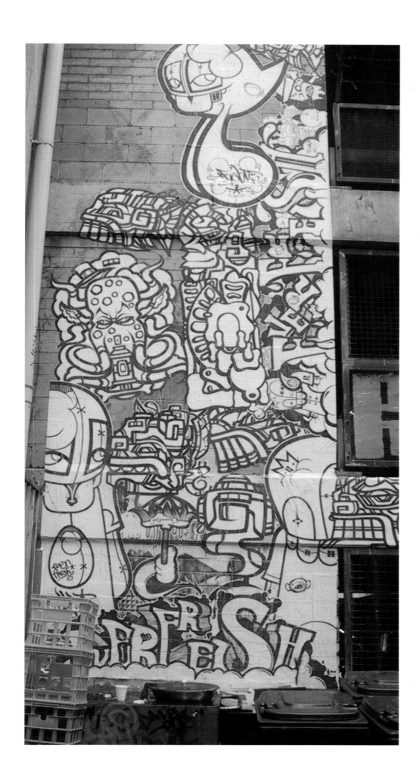

# Hosier Lane Posse

The Ever Fresh Crew (EFC) completed this paste-up in Hosier Lane on the day that another collaborative group completed a piece (pictured on pages 94 and 95) on another wall of the same lane.

EFC members Phibs, Reka, Wonderlust, Neuro, Lister, Rone, Meggs, Prism and Sync used wallpaper glue and extensible brooms to paste this as high as they could on the wall. They accessed the wall from different levels of the cark park when they needed to get higher.

The result is spectacular and brazen, particularly given that the work was created on a Sunday lunchtime in the centre of Melbourne.

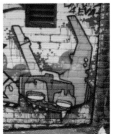
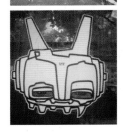

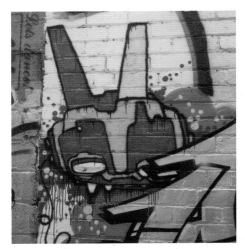

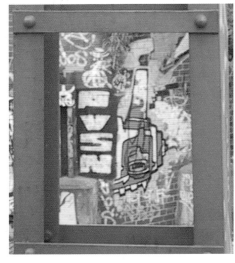

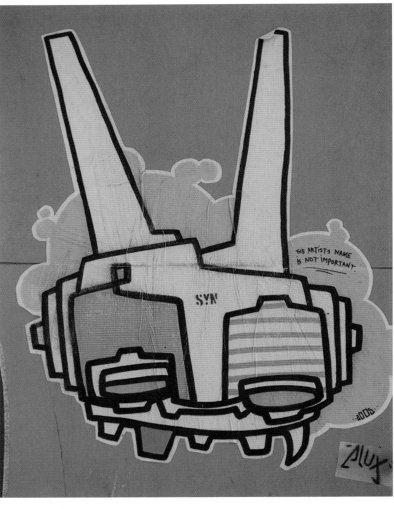

THE ARTISTS NAME IS NOT IMPORTANT

# SpektapodS

Sync's character, the Spektapod, has appeared everywhere from railway station entrances to city corners. It has been pasted as stickers and posters; sketched, sprayed and drawn on walls; and painted in a profusion of colours. Unlike other artists, Sync's work tends to evolve gradually rather than in leaps and bounds. His mutant ghettoblaster-

like alien with teeth has developed a following across Melbourne's inner suburbs. Aficionados are waiting for the next generation, and like Alien, it promises to be bigger, badder and ever more spectacular. Engaging and instantly likeable, Sync speaks freely about his unique work and style. His insight into his own approach makes him

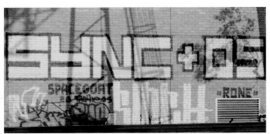

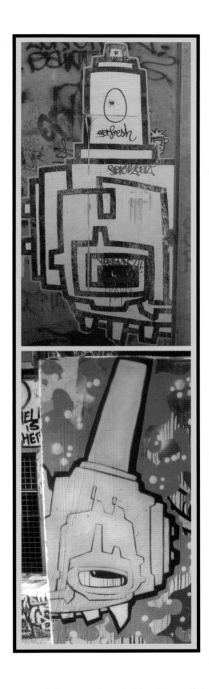

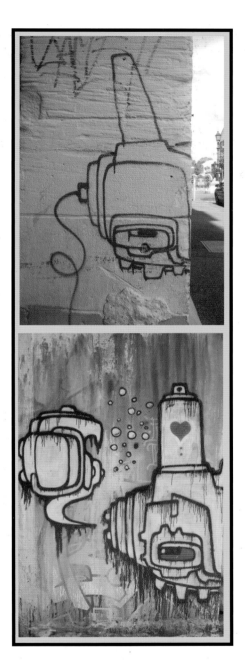

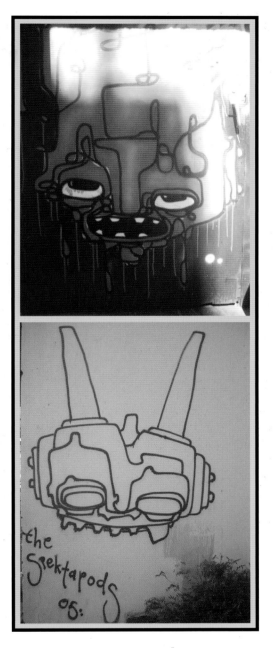

one of the most enlightening artists to talk to. He views the walls as a grid. By visualising a wall with X and Y axes, he can enlarge and reduce his Space Goats without spoiling the proportions. His ability with colours, especially in terms of balance, is also obvious in these examples. Like many other artists, he moved to Melbourne from Adelaide to practice his art (Adelaide seems to be a prolific production line for high-quality street artists, and many of Melbourne's well-known graffers started out in that city).

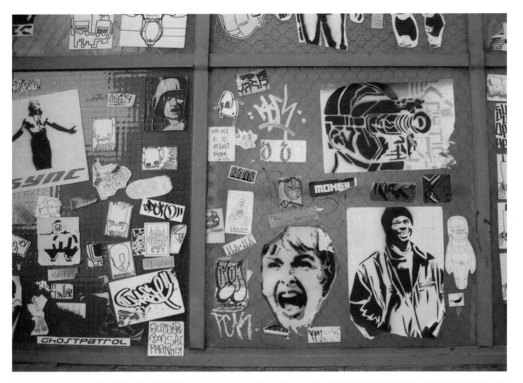

# City message boards

Just as Melbourne has a couple of dozen walls used regularly for stencils, it also has standard sites for paste-ups and stickers (a smoother surface is required for the application of stickers and paste-ups). All over the city centre – especially on Hosier Lane, Little Latrobe Street, and just off Little Lonsdale Street – there are specific locations which regularly attract large deposits of new stickers. The most prolific artists seem to be those who are well established on the stencil scene, although this may simply indicate that their work stays around for longer because of the respect they get from other artists.

Optic, Ha-Ha and particularly Sync have been busy here.

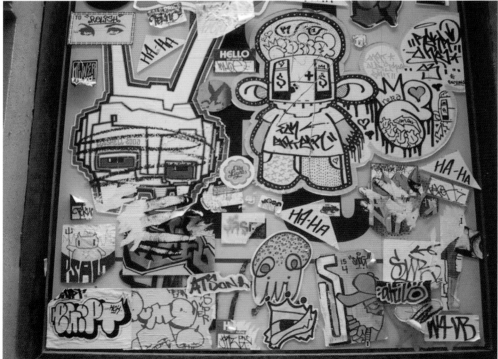

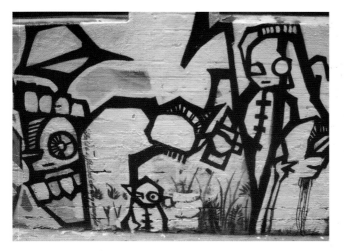

# Graffiti: The walls are talking

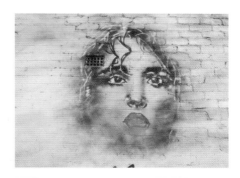

People have been drawing and writing on walls for millennia. In Australia, there are some stunning examples by Aboriginal artists who lived tens of thousands of years ago. Modern free-hand graffiti takes many guises, and the following pages illustrate the diversity of forms and styles.

Most graffers use paint from spray cans, but some also use paintbrushes or rollers. Rollers allow quick but crude application of paint. They are used either for large letters or to create a background over which to spray. Paintbrushes tend to be limited to legal street art as using them is time consuming and brushes require cleaning, whereas spray cans are simply thrown away.

While the can itself is jettisoned, the nozzle is removed and kept. Experienced artists use a collection of nozzles that allow variations in the speed of the flow and width of the spray. Old nozzles are modified to build up this range.

Dripping can be reduced by holding the can away from the wall, spraying a really fat line, or by using a nozzle that reduces the speed of flow. The angle at which the can is held is crucial to achieving evenly applied paint. Most artists mark out the space and practice on paper first.

Experience is the best way to perfect technique, and practised artists can create technically proficient pieces at a phenomenal rate.

**The face shown top right uses tones and fuzzes colour without the use of bold edging as a way of rendering the image from a distance**

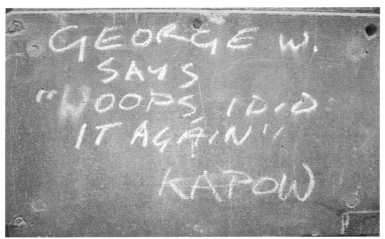

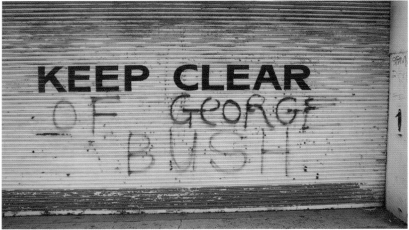

# Political graffiti - editorials of the protesting class

From the 1960s to 1980s, most political graffiti was created as text written directly onto a wall, bridge or train. It is harder to find graffiti in this form today, as stencils have become increasingly popular. Nevertheless, there are still some excellent examples.

The anti–George Bush chalking pictured at top left uses lyrics from a Britney Spears song. Spears' music is poppy and empty of any real substance, but because it gets so much airtime in all forms of the media it is immediately recognisable. The use of such familiar lyrics strengthens the impact on the viewer. Now whenever I hear that song, I think of George Bush dropping more bombs.

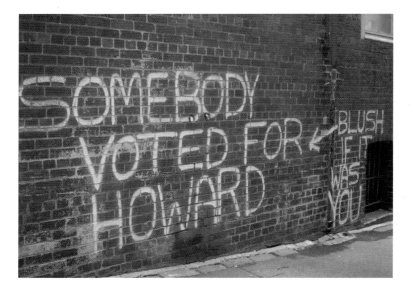

The graffiti shown at bottom left was written after Australia's 2004 Federal Election between the incumbent Liberal Prime Minister John Howard and Labor's Mark Latham. I wonder if Howard voters are blushing?

I haven't been able to capture some of my favourite political graffiti on film. Two of my favourites date from the days immediately preceding the 2004 Federal Election. One slogan inscribed on Richmond station told people to "Hunt Coward". The other, on a billboard at Malvern station in Melbourne's affluent south-eastern suburb, was based on the slogan for the Alien vs Predator film, and read "Whoever wins we lose".

Sometimes graffiti can be interpreted as direct political comment even when it may be making a broader social point. In 1996, artist Karen Linder, in association with the Victorian College of the Arts and Transfield Obayashi, a construction company undertaking a major engineering project in Melbourne, was commissioned to create art work along the hoardings of the project. The text included such slogans as: "Why do you control?", "Why are you afraid of your vulnerability?" and "Your superiority is an illusion".

This artwork is rumoured to have incensed the then premier of Victoria, Jeff Kennet, and the artwork was covered up during a weekend celebrating the state government's four years in power. Jeff Kennett commented only that "Every artistic form is free to express itself as it sees fit. But if the art community want, as they do, corporate sponsorship, they must decide whether to bite the hand that feeds them".

## Love notes

Simple expressions of love have been scrawled on walls by ordinary people for centuries. Street artists may also choose this medium to express their feelings to the people they love in a direct, beautiful and completely public declaration. The sentiments in this type of graffiti always remind me that it is OK to say what I feel and believe. The examples here are more sophisticated versions of the simple 'X loves Y' type of message.

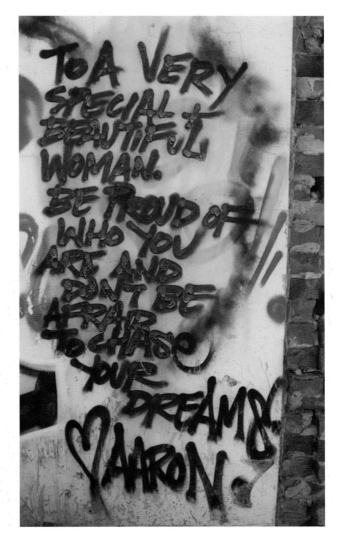

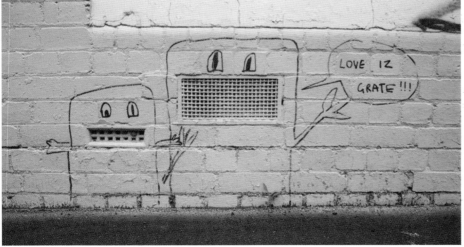

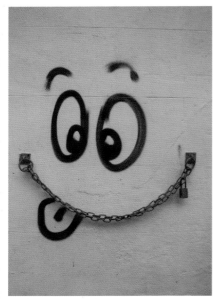

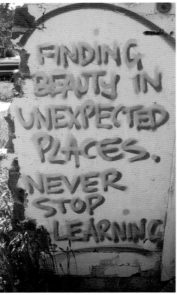

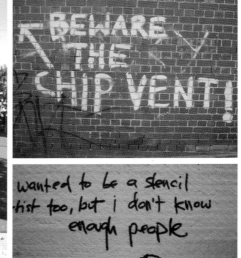

wanted to be a stencil artist too, but i don't know enough people

# Some states of mind

Graffiti slogans are not always a political statement or a declaration of love. They can be rhetorical or colloquial. They can be weighty or trivial reflections on society. They can be sincerely emotional or they can be filled with cynicism and satire.

The graffiti displayed on these two pages is not abusive, political or anti-establishment in any way other than its very status as graffiti. The pieces suggest only that their creators have a quirky creativity, and time and inclination to write on walls. The world would be a poorer place without much of this type of graffiti.

Melbourne graffiti is rich in witticisms, innovative styles of writing and clever use of the environment (see for example the 'MEOOO' piece at the centre of the opposite page).

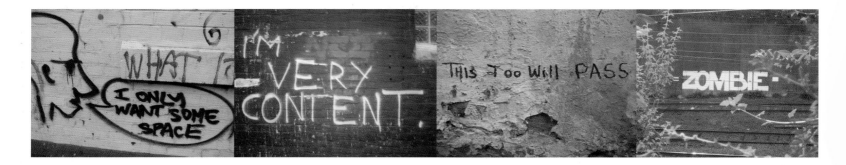

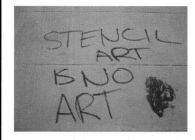

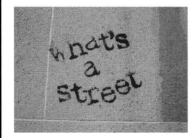

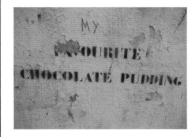

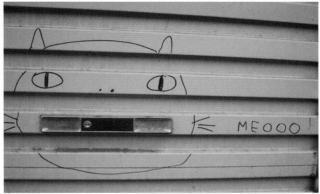

# Word balloonists in the air

"When graffiti is original or thought provoking, I really appreciate it. It is usually unexpected, and makes me think about things that I would normally not be thinking about. Some of the most memorable quotes I have read have been on walls, such as: 'Dealing with Centre Link is work for the dole'; 'Fight fire with fire and the world will burn'; 'Women are dying to be this thin' (on an advertisement featuring a very skinny woman)

And something about a particular forest being able to survive for millions of years, but can it survive another term of the Liberal government.

I still remember when I was about 10 years old seeing a 'To let' sign on a building that had been changed to 'Toilet' and thinking it was the most funny and original thing I had ever seen" – Scott, IT architect.

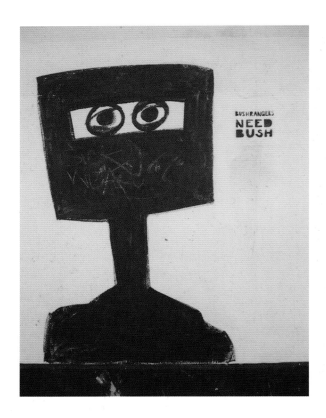

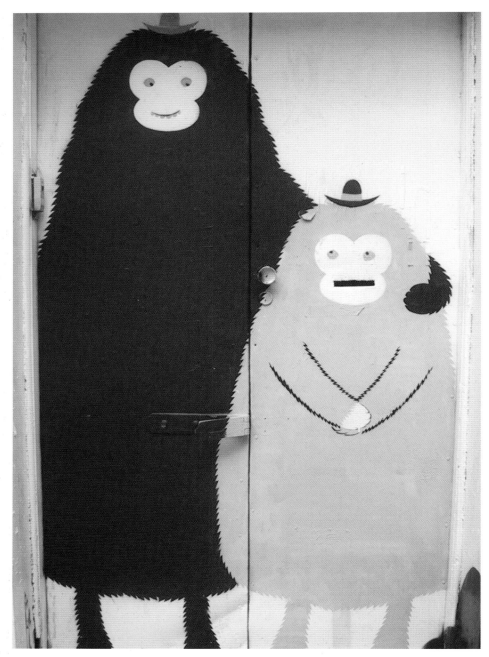

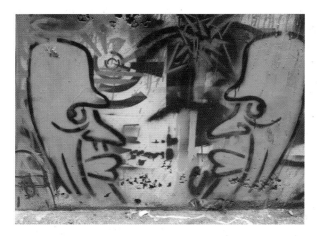

"Bushrangers need bush" is infamous in Melbourne. It actually dates from when it was used as a political slogan in the early 1990s, but serves just as well today as a message to Australia's federal government. It relates to the conservation of the Tasmanian wilderness and forests, widely agreed to be among the most beautiful in the world. I must admit I initially interpreted it entirely differently.

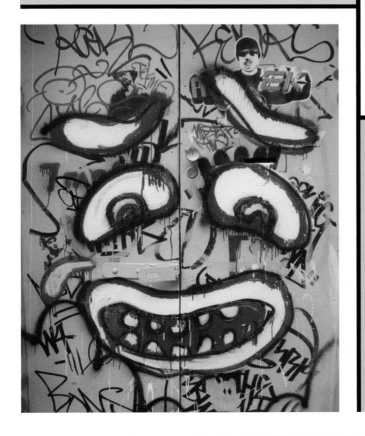

"graff is better than sex or footy" - anon

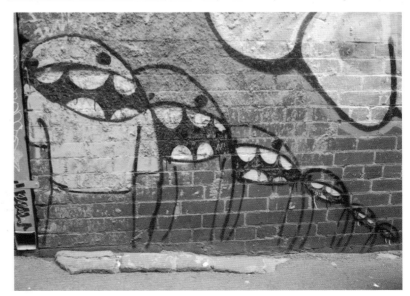

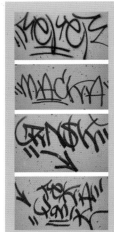

# Does anybody love tagging?

A tag is the signature-like scribble, often indecipherable to the average passer-by, that records the presence and identity of the writer.

Many people detest tags. They resent their ubiquitous presence, and see them as mindless and unsophisticated. But the process of creating a tag is taken seriously by writers. A tag must have credibility: no stupid words or names. Anything identifying the writer legally would be a problem, so initials, nicknames or other personal identifiers are out. Using another writer's tag, or a famous name or a stupid word will leave the writer open to ridicule. If the tag is long, a shorter version is required for when space and time are limited.

Tags are developed through hours of practice, they can take a year to perfect. The goal is to create something that stands out – some writers are more successful in achieving this than others.

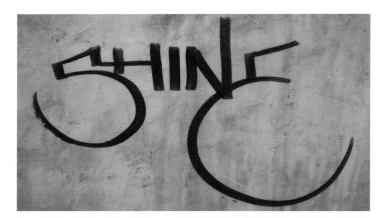

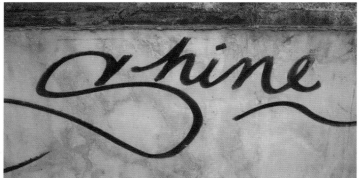

"just writing your name isn't really graffiti all it is, is having a pen and letting people know where you are and where you have been" – Melbourne street artist.

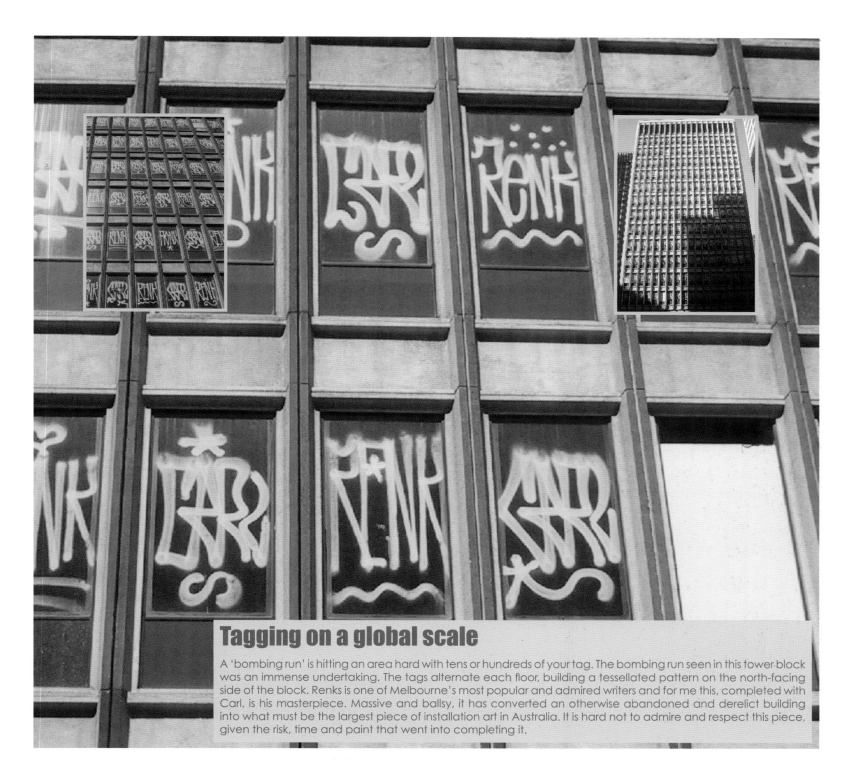

## Tagging on a global scale

A 'bombing run' is hitting an area hard with tens or hundreds of your tag. The bombing run seen in this tower block was an immense undertaking. The tags alternate each floor, building a tessellated pattern on the north-facing side of the block. Renks is one of Melbourne's most popular and admired writers and for me this, completed with Carl, is his masterpiece. Massive and ballsy, it has converted an otherwise abandoned and derelict building into what must be the largest piece of installation art in Australia. It is hard not to admire and respect this piece, given the risk, time and paint that went into completing it.

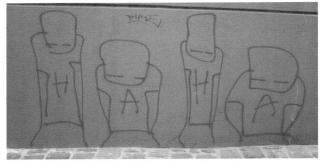

# Tagging with symbols

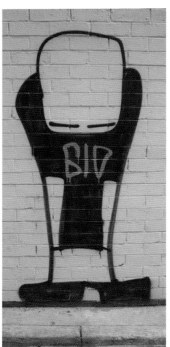

Tags do not need to be text based. The examples shown here still constitute tags, although they are image-based rather than text-based. Like text-based tags, these images are repeated from location to location as a symbol of the artist, a 'signature' of a sort.

Tags and signatures are not quite the same thing: they are created for different reasons. Signatures identify an individual uniquely for legal purposes, whereas a tag is used to identify an individual but not to the authorities. Rather it is used to identify the artist and his or her work to the viewer and other writers. Thus, there is no obvious link between the text or image of the tag and the writer's real name.

Tags often develop from the doodling many of us did at school, developing a unique style of writing or drawing to differentiate ourselves from the person sitting next to us. Those that persisted developed highly stylised and easily repeatable signatures or images, that could then be transformed into tags.

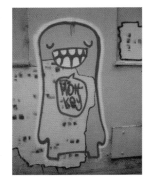

A tag can be a collective name used by a group of writers. "BRADDOCK", for example, is used by more than one artist.

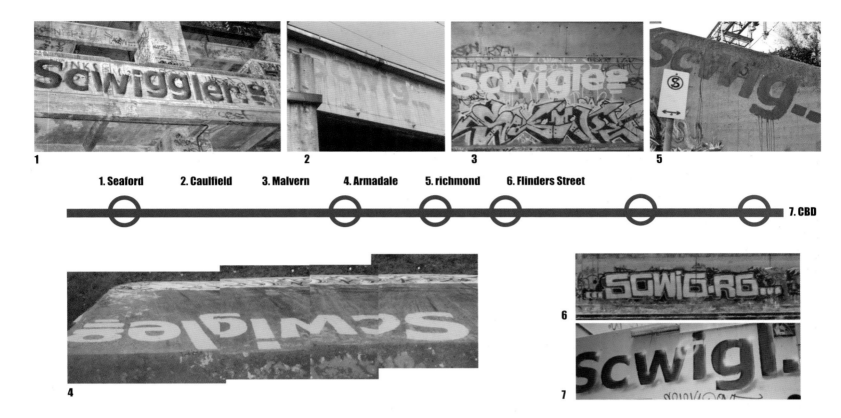

1

2

3

5

**1. Seaford    2. Caulfield    3. Malvern    4. Armadale    5. richmond    6. Flinders Street**

**7. CBD**

6

7

Taggers want their tags to be noticed and recognised. Obviously the style of a tag (including its complexity and readability) is key in creating something that stands out. The colour used is also important. Location (trains, walls, and stations, for example) and the positioning of the tag at that location (at eye level versus hidden from direct sight) will also have an effect. Repetition of the tag will make it more memorable, while a single tag placed amongst numerous competing tags will be hard to spot, let alone remember.

A few ozzie facts and figures about tagging
- 100-300 tags per night per tagger
- 10-30 tags per spray can
- a tag may take less than 5 seconds to complete (a piece may take up to 6 hours or more)
- Taggers tag every night or as little as once a month
- 50% will tag only their local area, 50% will tag anywhere
- 50% are part of a crew, the rest operate on their own or in pairs
- crews operate differently from gangs, primary interest is graffiti
- majority of taggers are teenagers, the average age is 15
- many taggers go on to piece

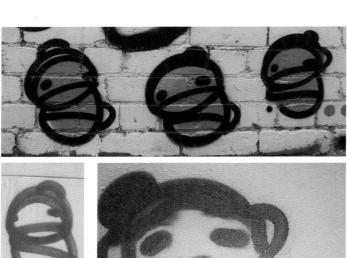
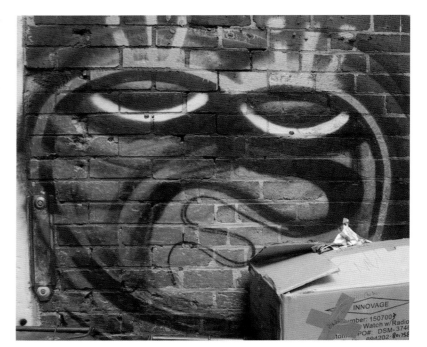

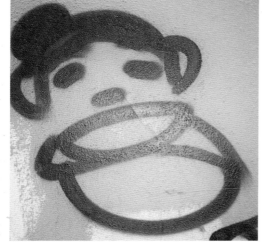
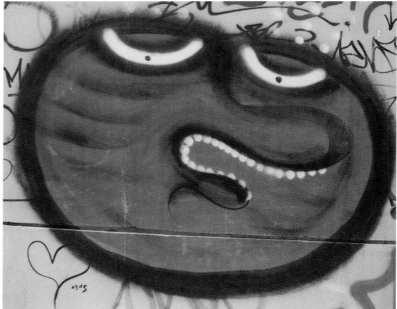
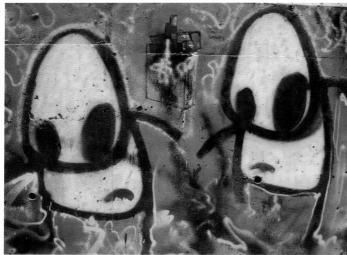

# Making myself known

Most graffiti is about the artist asserting his or her identity.

We all grapple with the question of who we are for most of our lives. We have a post-university crisis, we have a mid-life crisis, and then we have to re-invent ourselves when we retire. But the greatest pressure to forge our own identity is felt when we are younger, during adolescence.

For teenagers, developing a unique sense of identity is a 24–7 job. It drives every parent crazy. But we have all done it, and it helps us understand who we are, gives us direction and aligns our values. We don't function well without understanding who we are or what we believe in. When we figure out who we are, how we fit in, and we accept it, we are happier and have better self-esteem. We become more independent and responsible.

Identity is the ability to differentiate yourself from others, knowing your own individuality and uniqueness. When you know yourself you are better equipped to build social networks, and maintain friendships.

Defining identity is an exploratory process. You must experiment to find an identity that fits and that has a value system that feels comfortable for you to accept.

In defining your independence, you can be in one of four stages. If you have not explored different value systems, you can either commit to nothing, or commit to one that you are given, say that of your parents. Alternatively, you can be in the middle of exploring different systems and values, or you might have explored and adopted a value system that works for you. At this point you should know yourself pretty well.

Why is this important to street art? Psychology suggests that juvenile delinquents fit into the category of people who have not explored or committed to a value system. Graffitists are often perceived as delinquents. I genuinely believe this perception is wrong. The writers I have met are not delinquents. They are generally exploring ideas and they have a system they work within. Some have explored for longer and so have a more solid understanding of themselves. These guys tend to be the older, more successful artists. They strike me as being more together than most of us.

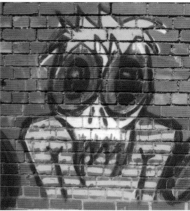

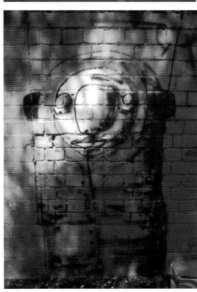

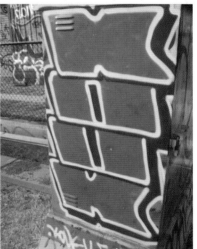

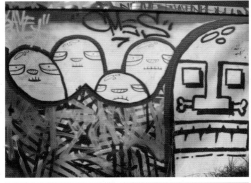

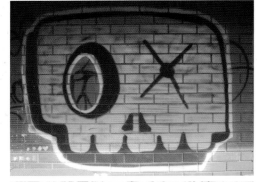
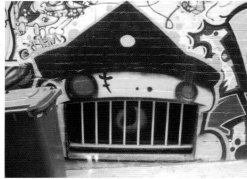

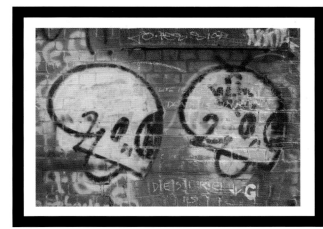

# Graffiti as art

Placing these images in frames gives them a kind of official status they don't have on the street. Any of these would have graced a gallery's walls. In fact, I would argue they were in a gallery – one freely available on the streets. But, as Ferris once said, "if you don't pay attention – it will pass you by".

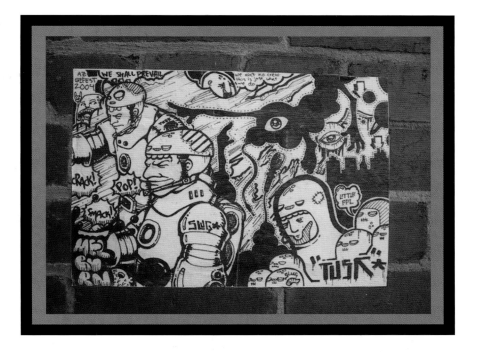

Permission is what differentiates vandalism from art in many cases.

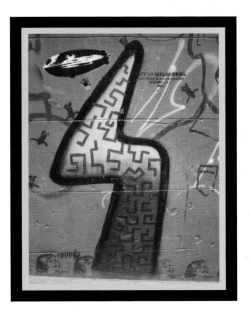

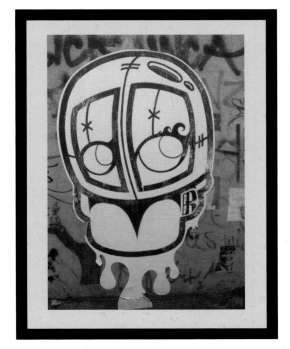

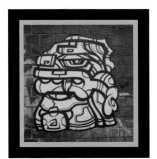

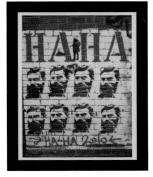

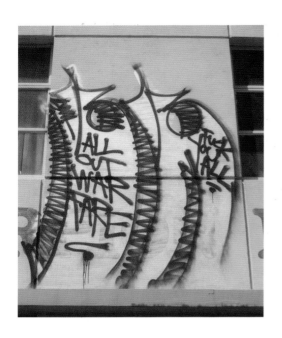 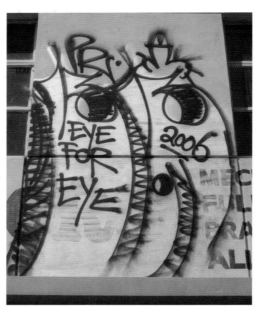 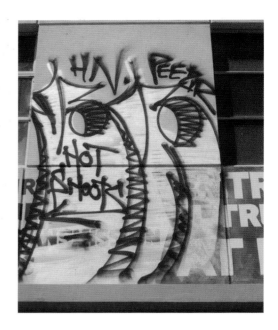

# Doodling goes public

The abstract forms on this page are reminiscent of doodles. Doodling is a form of private graffiti; graffiti is where doodling goes public. We doodle when we are not fully paying attention to something else: a lesson, a meeting or a telephone conversation. The importance of what we create when we doodle is probably lost on most of us. It can often be totally formless and meaningless, but as an adolescent it shows traits of identity formation. It is universally the source for most writers' first tag.

As you can see from this book, a tag can be as simple as an easily readable sans serif font, or as complex as an almost ndecipherable wildstyle serif font. It can be a nickname, icon, symbol or index which represents the artist's identity.

Because street art is so closely tied to its creator, street art can give the viewer a chance to peep into someone's life undisturbed. The astute observer will over time begin to see patterns forming. These are not always immediately apparent, but gradually once comes to recognise the styles of writing,  ppreciate their development, and notice

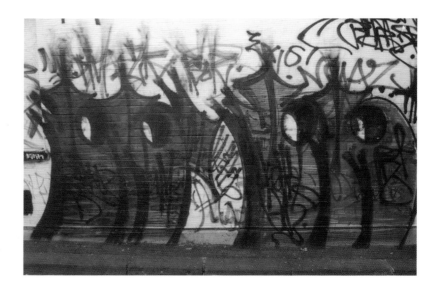

how  styles can be developed in relation to each other. The artists' behaviours and the social relationships between them begin to emerge. At this point you can begin to define personalities for these unseen artists.

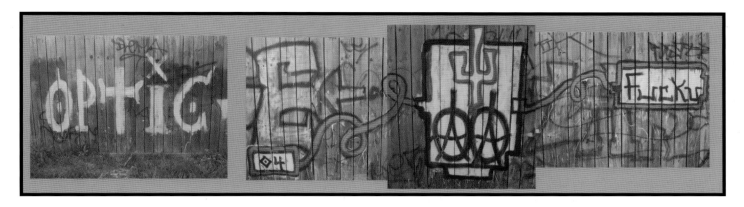

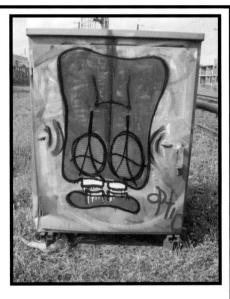

# OPTIC

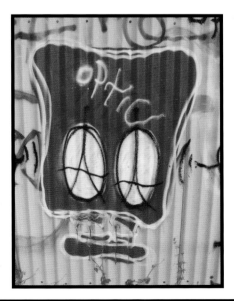

While most graffers follow a path from tagging to throw-ups to piecing, Optic has successfully broken into the graffer's world from stuckistry. Many who jumped on the stencilling bandwagon jumped off again just as quickly. Optic is one of only a few to have gone hardcore.

Having followed Optic through stencils, a brief foray into plaques, stickers and posters (including a number of political works expressing opposition to the war in Iraq), I discovered these in Northcote, near what must be his stamping ground.

Optic's highly stylised character is developing as his trademark. It will be interesting to see what new challenges and directions Optic takes in the future. With growth in confidence and technique, and ever-increasing experience in painting freehand, his style is sure to evolve.

  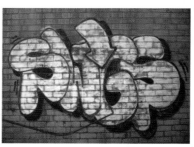 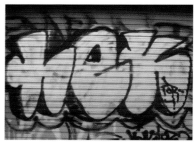

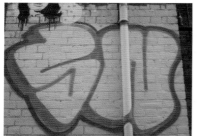 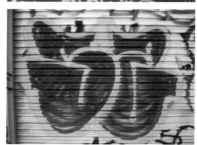 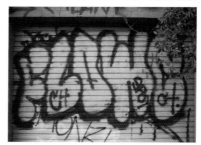 

# Throw-ups can grow on you

An unfortunate name for this distinct type of graffiti, but an entirely appropriate one. Throw-ups are quick, hurried affairs, usually done in a spree. Perhaps one of the hardest types of graffiti to appreciate, throw-ups do grow on you. I had not intended to include them in this book, but was severely reprimanded by a number of local artists for missing out a key link in the development of a typical graffiti artist. They are crucial stage for artists to refine their style and learn their craft. It makes logical sense that writers who tag and progress to full pieces do so via a stage of throw-ups. It helps improve the spraycan skills required and build an understanding of which surfaces and colours will give the best results.

**The image at bottom left may look like a throw-up, but is in fact a complex tag or piece. Such a distinction is sometimes apparent only to the artists themselves.**

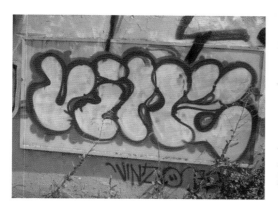

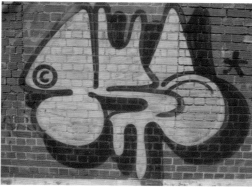

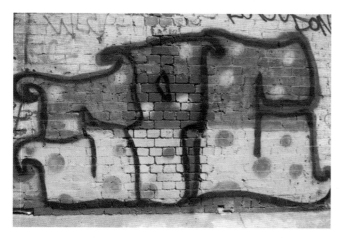

# Short order art on the run

Having being forced to pay attention to throw-ups where previously I would have spent little time on them, I can now recognise the skill apparent in those shown here. Given that throw-ups are generally put together in less than five minutes, the writer must be quick, precise and highly practised at the image being created. Artists will typically draw the outline in the fill-in colour, then fill in, and then finish with the outline. Using this method provides the neatest finish.

Renks, whose work is pictured below right, is considered by many to be a masterful throw-up specialist, and his work is everywhere. Vespa's 'lunatic throwey' (bottom left) has been much admired by other writers for its complexity and nuttiness. The piece by SPC (centre left) is technically not a throw-up as it uses more than two colours, but it provides a useful comparison.

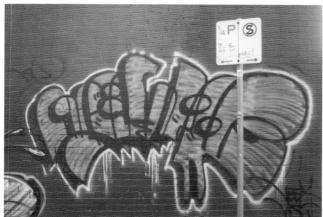

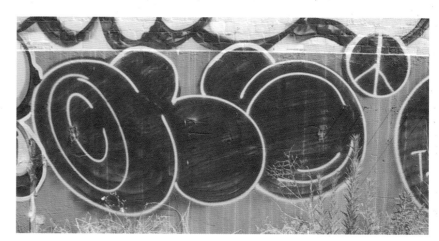

# Murals and pieces

Complex and detailed, the murals and pieces shown on the following pages are undeniably of outstanding quality.

Piecing is tough work. Because a piece can take hours, with artists sometimes returning to the site several times, the risk of being caught is high. Pieces are generally completed at night, although the more brazen might venture out during the day when the risk is even higher. At night, light is minimal, coming only from ambient street lighting, and a torch only illuminates small portions at a time. It is undertaken in all weather. Given the conditions, these guys are damn near geniuses.

Pieces vary considerably in size and therefore so does paint consumption. A standard railway line piece measures 10 to 20 feet lengthways by 10 feet high, requiring about ten cans. A typical train carriage measures around 60 feet by 10 feet, and requires about thirty cans. The number of cans used will also depend on the number of colours needed.

The paints that gets used quickest are black and white, so more than one can of each would be required for any one large piece, and at least one can for each of the colours to be used. The artist must carry all of these cans easily and quietly. The right can must be accessible but easy to stow quickly if the work is interrupted. If the work will be completed over several days or nights, the artist needs only carry those cans required to complete a given phase of the piece.

Pieces are typically painstakingly planned. They are designed on paper first, the necessary colours are then acquired, the site is reconnoitred, and the surface prepared.

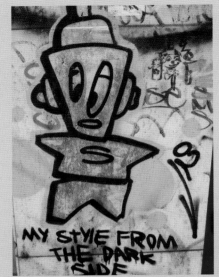

**This piece, a 1990 painting by Mike Brown a few doors from his home in North Fitzroy, is being considered for heritage listing. If it is successful, it will be the first piece of graffiti to be listed in Melbourne. It was part of an exhibition Brown held in 1990, and was dedicated to a woman called ngela and celebrated the notion of romantic love. Brown rallied against elitism in art, with a view to making it more accessible to the general public.**

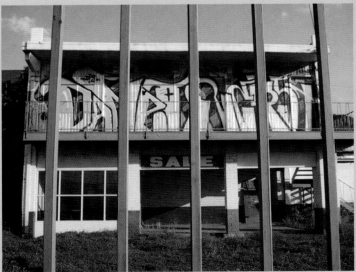

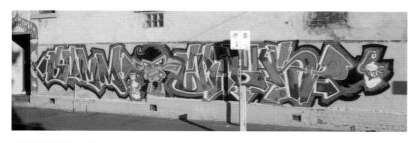

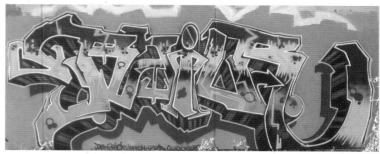

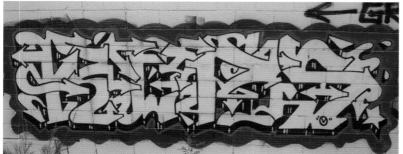

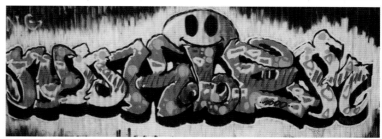

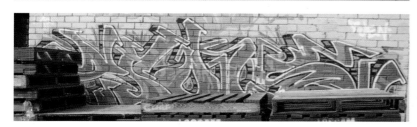

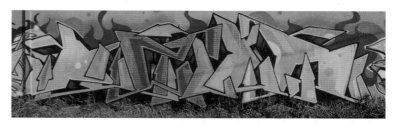

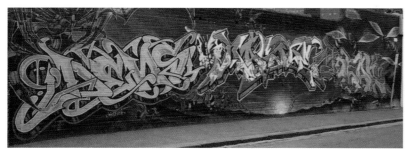

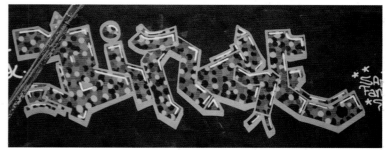

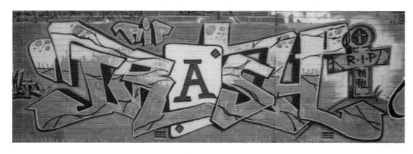

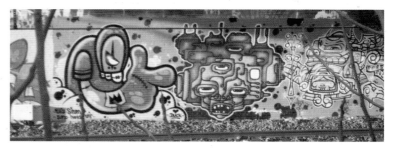

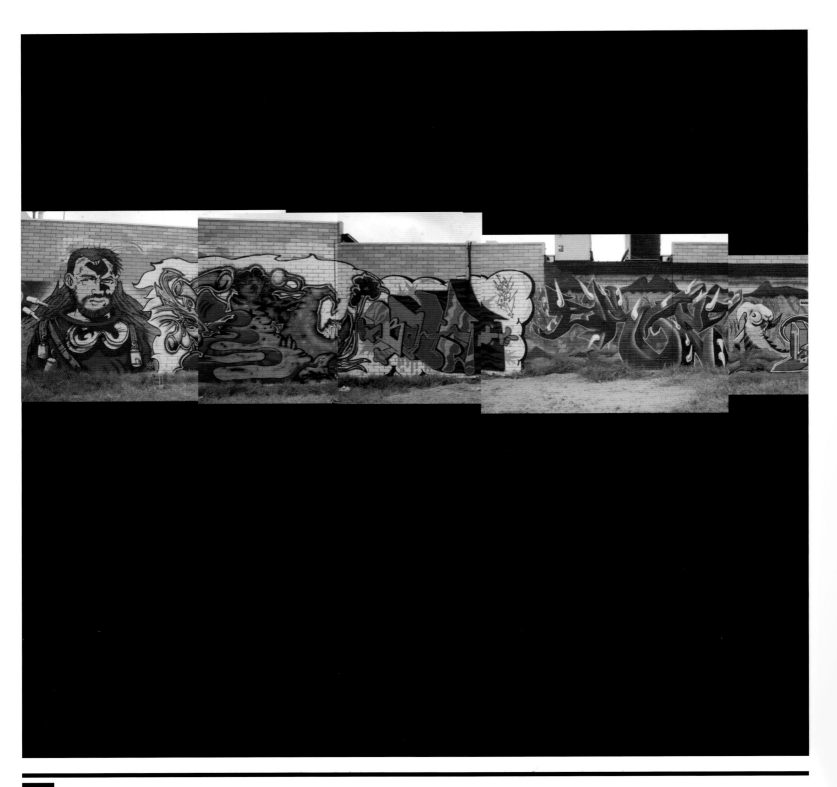

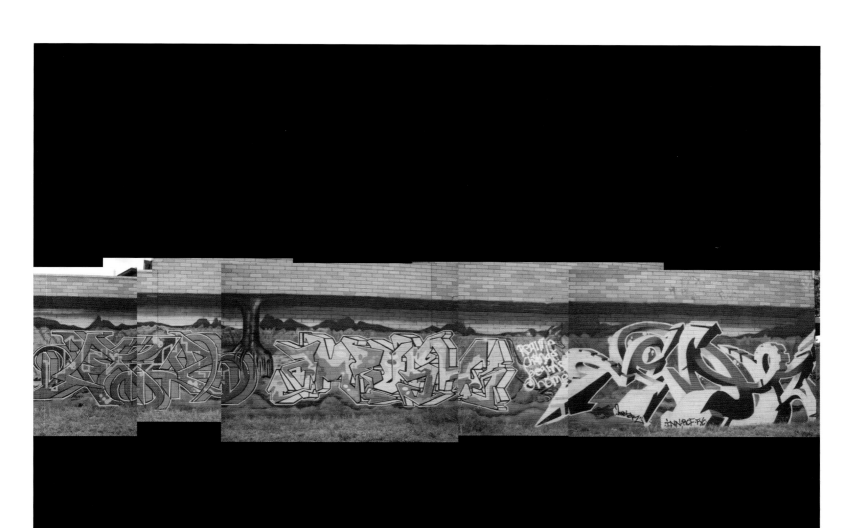

Murals such as these border railway lines the world over. It would be hard not to agree that what would otherwise be a drab environment is enhanced by the creative work of the artists.

# Sumo 178

Sitting quietly in his office, finalising type settings for the latest issue of Acclaim Magazine is a young man in his twenties. He is a tertiary educated professional graphic designer and is married to his high school sweetheart, Natasha. He is a writer, a designer. We know him as Sumo.

From first impressions he is almost too clean, he has no vices, not gambling, drinking or smoking. This he attributes to his younger years as an athlete, 11 seconds flat for the 100 meters, and his preference to be out at night writing on walls rather than getting hammered with mates at parties.

As a writer he not only spray-paints walls, he is also a typographer, a calligrapher and a designer. One of his inspirations is Amsterdam writer Delta who has also forged a career in graffiti-based design. Through this interest he has been able to establish a career where he is self-sufficient through his design and creative skills.

His story is much like other writers, it follows a classic development path. He studied at one of Melbourne's schools known for producing Melbourne graffiti talent, Box Hill Tech, home to Crime Wave, Puffing Billy Posse (PBP) and In Full Effect (IFE).

Graffiti is his art and it was his first love. His 16 years of active service kicked off after being inspired by two pieces seen on the way to school. One by PBP: Cism & Der for the PBP Boys, with a Mr Potato Head emblazoned at the centre. The second was a "Panel" filling the side of a passing train*.

Writing first under the tag of Sumo178 (he has an ongoing interest in Japanese culture and writing techniques), he was initially known for his fat style of writing, although this became increasingly angular and sharpened with the flow of the lettering comparable to the form of a flying dragon. DMA's Tame is the first to coin the name "The Savage Sumo" which has stayed with him since.

*A "Panel" is a painted train carriage, in this case a Window Down – Door 2 Door.

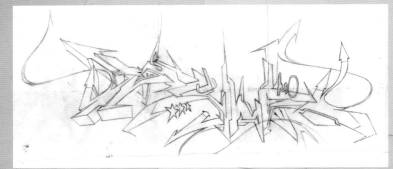

Sumo's sketch here is shown to compare the intended piece against the finished item. Sumo ran out of wall, and had to re-dimension the piece to fit it to a shorter length of wall on the day. Note the "T" for his wife 'Tash' on this and the other pieces. In this case, just after Sumo at the base of the text.

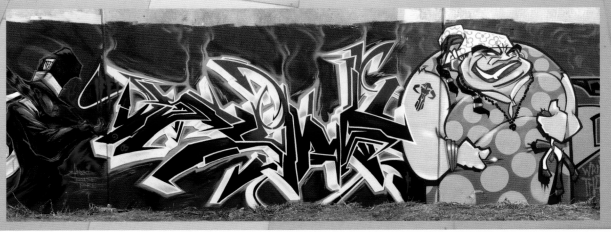

"Writing for me is about style. Each letter should look good on its own. An "S" should look like an "S", not depend on the rest of the piece to make it work, for me it should always look aggressive and must always have flow"

This aggressive writing style remained with him, at least when writing under the pseudonym of Sumo, and his techniques developed along the same lines as many other writers, through sketching, bombing, throw ups and finally piecing. Sumo has remained the stalwart tag of choice while other tags are maintained for different purposes.

Sumo's driving force has changed over time. Initially it was about getting up, then it began to be about the quality of the work "getting up with skills", and "having the best style around". Now it is for pleasure and self-satisfaction. As with otherwriters, originality is treasured, as are the best spots, which tend to be well lit and highly public, so it is also about risk taking and one-upmanship. Now he works as a freelance designer, working across several magazines and other media. Unlike many of us he spends his life doing work he loves and his preferred subject of choice, graffiti and hip-hop.

He hopes to be able to continue roaming through life doing what he does today, creating art on canvases such as shoes, vases, walls, glass ware and cars while developing other opportunities through his design career, magazines and company.

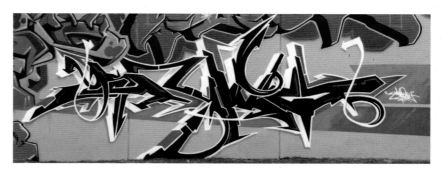

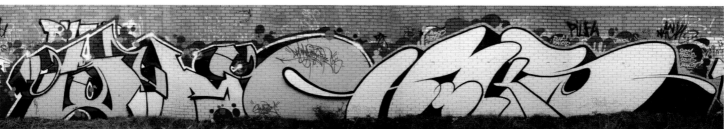

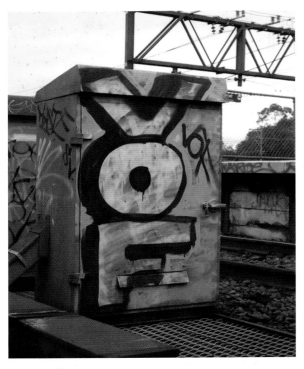

# On the lines

Writers want respect from other writers. Such respect is dependent not only on developing an individual style but also, within some circles, taking plenty of risks. Writing on rail lines used by middle-of-the-night freight trains, or graffing in the city patrolled by guards or police, are both high pressure and dangerous situations. The art on legal walls and in skate parks may be of better quality, but there just isn't the same respect.

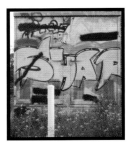

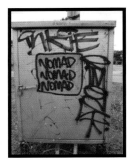

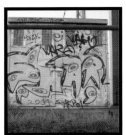

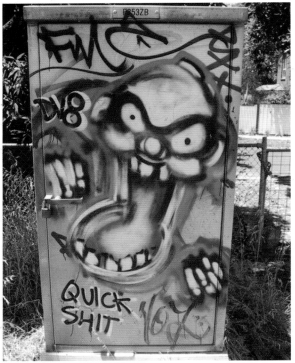

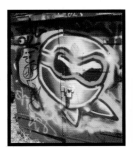

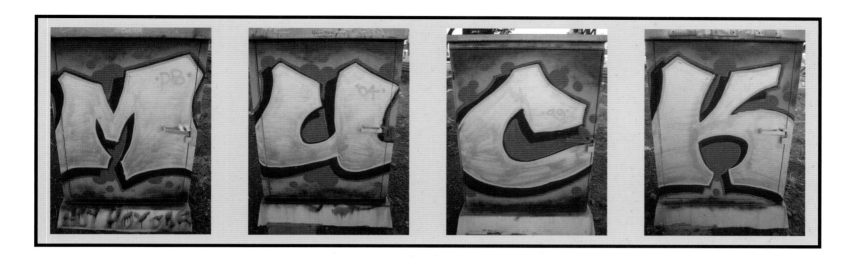

# Unsafe zones

Politicians and the public sometimes claim that graffiti makes our streets and railway lines unsafe. While it is certainly true that it can make people feel unsafe, it does so because it illustrates that our streets and railways lines are not policed and are prone to misuse. If they were safe and protected, then there wouldn't be any graffiti. Graffiti then helps us to navigate ourselves away from areas of potential danger.

Graffiti on the interior of trains triggers a greater level of fear in many people. We travel in trains, so the chances of interacting with writers is greater and therefore so are the perceived dangers. Focusing on reduction of this form of graffiti rather than the graffiti along the lines would have a greater positive impact and lower cost than total zero-tolerance policies.

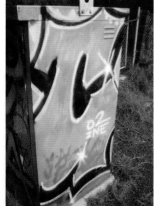

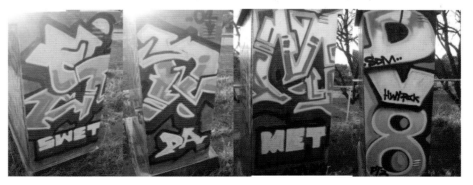

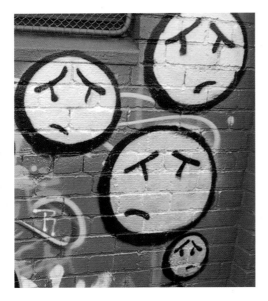

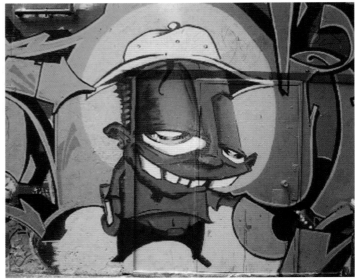

**Graffiti's face:** The images over the next five pages have been selected to illustrate the vast array of characters used by graffiti artists. The wealth of creative expression is phenomenal. The artists and writers continue to develop new characters, or develop the personalities of specific characters. Following the development of a character by looking for the next 'piece' on a wall is like waiting for the next edition of your favourite comic book. And as well as an ongoing story-line there is the ongoing development of the artist's style to follow.

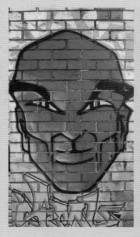

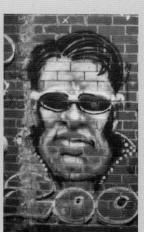

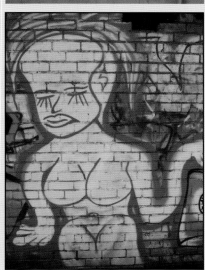

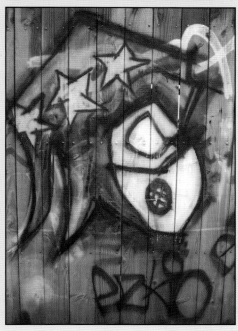

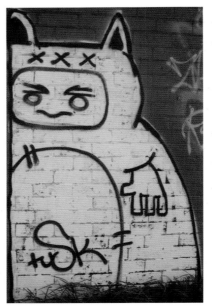
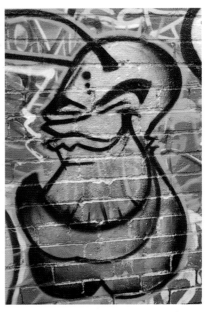
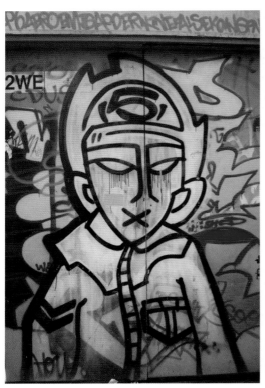
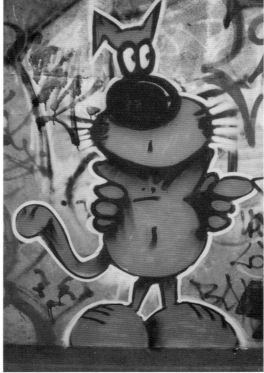
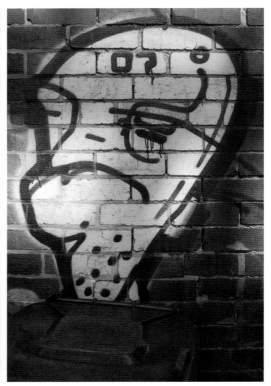

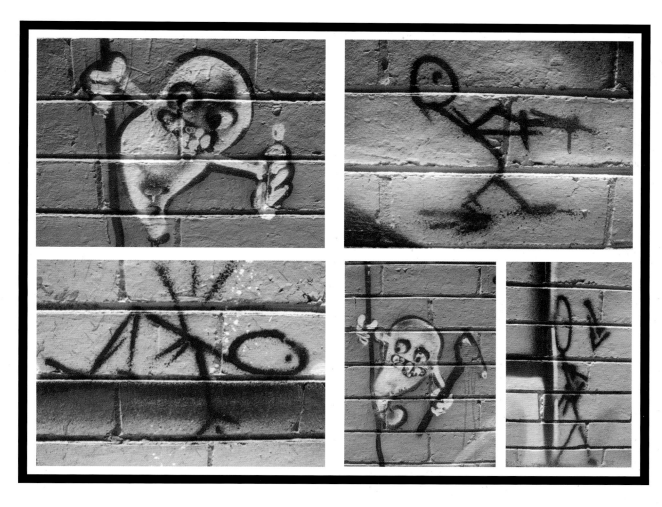

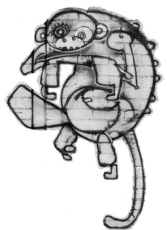
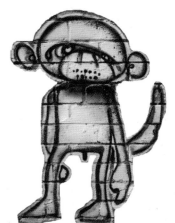

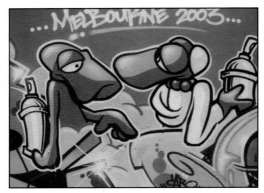

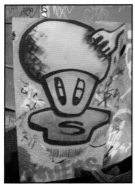
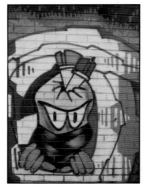
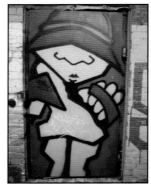
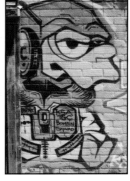
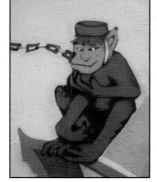
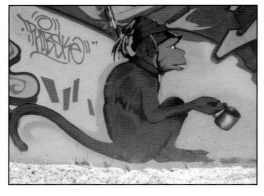

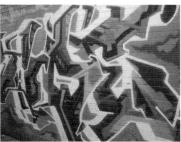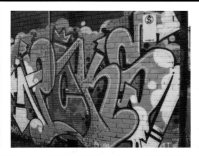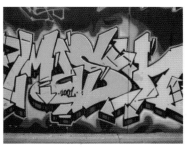

# Stepping out of the typographic square

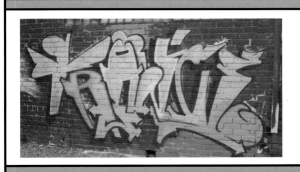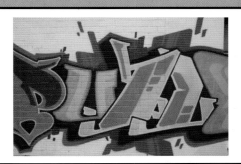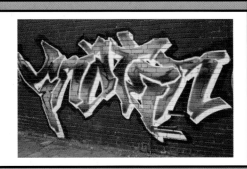

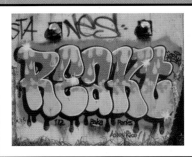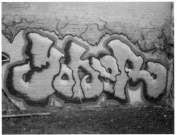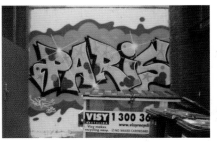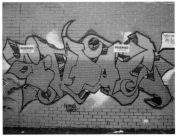

Graffiti artists whose work consists mainly of letters walk a complex path. They want their writing to be 'read', but they want to develop a unique and recognisable style. They may want their work to be understood by their peers, but not by the public. They have to follow some rules governing legibility, but be innovative. Each artist has to find their own balance between the limitations of the written form of graffiti and the opportunities it provides for creativity. Guidelines for achieving legibility are fairly basic, and how closely they are followed will depend on the artist and their understanding of their audience. Legibility can be defined simply as the ability of the audience to read the text, and 'reading the text' can mean the audience's ability simply to recognise the artist's work, even if the actual text itself is indecipherable.

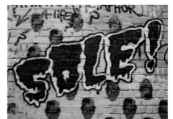
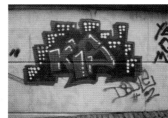
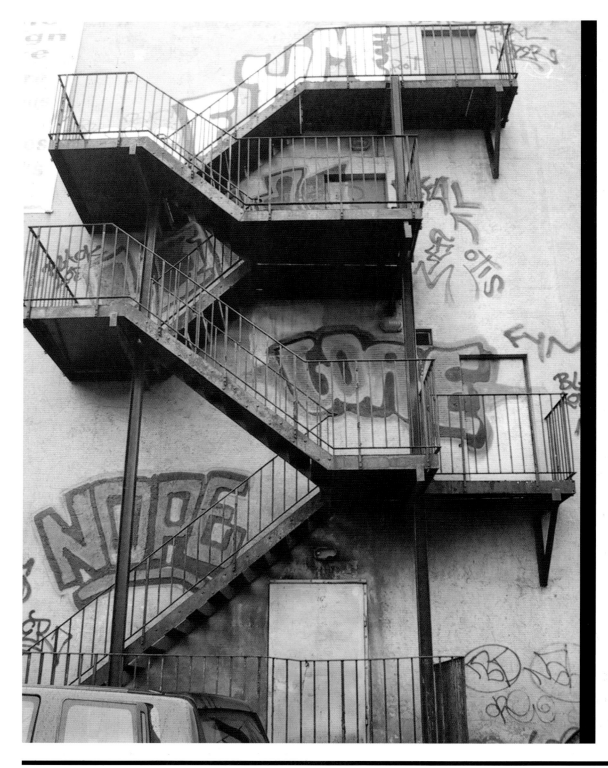
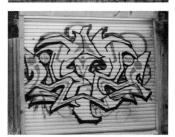
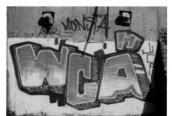

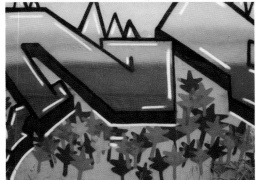

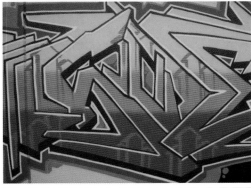

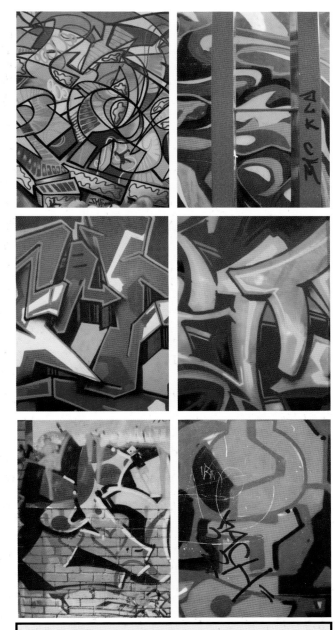

The general strategies for making text legible include: understanding the effect of ambient light; being aware of the distance and angle from which the text will be read; selecting or painting an appropriate underlying colour over which to write; using appropriate colours for the text itself; spacing letters and words far enough apart so they are distinguishable; ensuring letters are clearly different from one another.

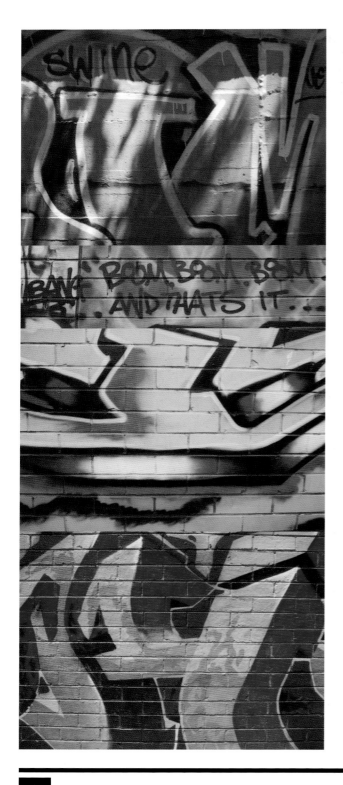

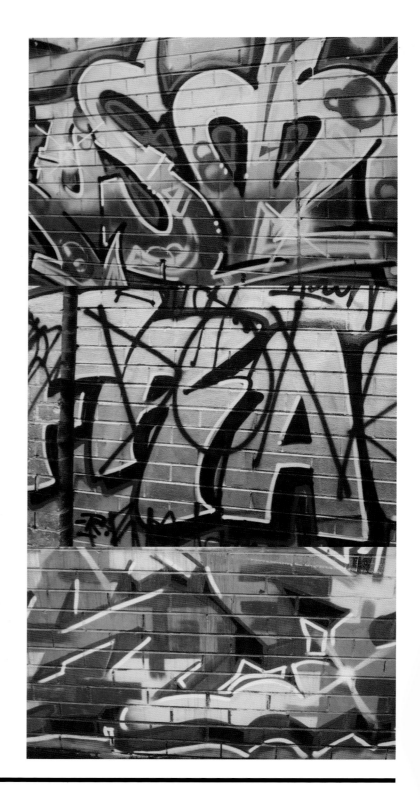

This piece is in the centre of a 100-metre long wall in Collingwood. The shoes and handbag pictured here were only temporary; the second-hand items set in front of the wall are regularly replaced. One month it will be a broken brolly and an old rain coat, the next a pair of gumboots and a shopping bag with newspapers. I have no idea if the constant change is intentional.

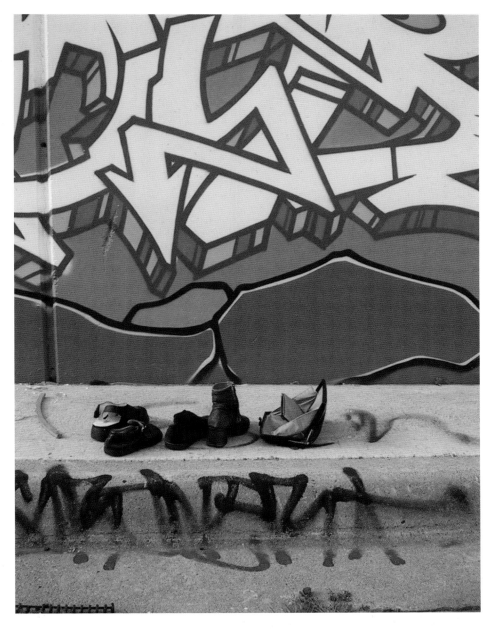

Typography can add extra meaning to the definition of the words themselves. For example, particular fonts can symbolise ages (Times New Roman is old-fashioned) and places (Broadway evokes American theatres).

Similarly, a graffiti writer can use the typeface they have developed to indicate emotion, for instance, or to capture a sense of movement. Letters might flame to signify heat, dazzle to symbolise light, or incorporate arrows to suggest direction.

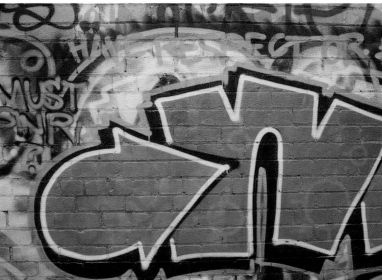

# Texture and colour the writers' tools

Writers must take into account the surface upon which they paint: its texture, its ability to absorb paint and its qualities as a background colour. A dense colour on top of a dense colour is hard to decipher.

Much of the graffiti along the rail-lines is 'prepared' first. The writer will paint a lighter background, beige, pale blue or white, before going back and writing over the top. Some artists practice on paper first, to help determine the best colours for legibility and effect. Experienced artists require less preparatory work.

For the writer, legibility in its strictest sense may not be as important as being noticed or recognised. Obviously, if the work is not noticed it will not be read. A writer's style is more like a logo, a trademark or a signature than simple text. Generally, the more noticeable it becomes, the more memorable it becomes.

Melbourne writer Scwiggler, whose work can be seen on page 81, has a highly noticeable, recognisable and memorable style. The font, the colour, and the positioning of his writings are consistent and the quality is maintained in every work.

He dominates the Frankston train line, with the work far enough from the trains to be clearly noticed. 'Scwiggler' is always written in a highly legible, stock-standard sans-serif font, in large, pale letters on a dark background.

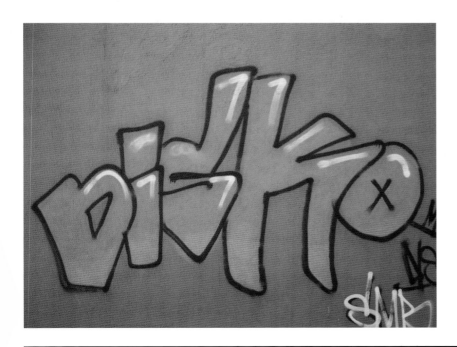

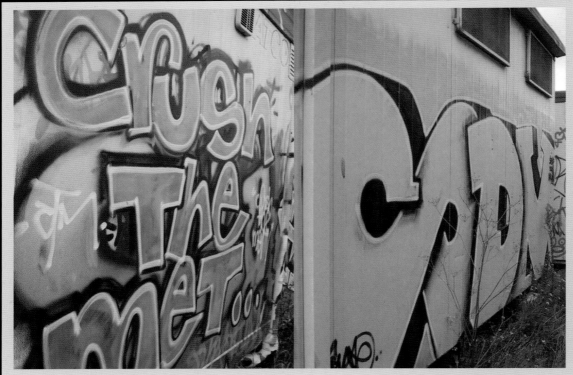

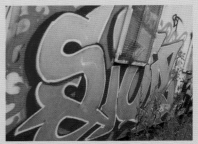

## Crush The Met

Crush the Met (CTM) takes its name from Melbourne's public transport system, which is known as the Met. The crew concentrates on graffing along train lines.

Australian transport regulations relate to destruction of property, criminal damage to property and to the appropriate and expected conduct of passengers.

The regulations stipulate that a person may not without express permission of the transport operator, write, draw, paint or affix a word, representation, character or poster on or to a passenger vehicle, or to any part of railway transport property and premises.

In each state penalties for non-compliance apply.

Typical penalty: $2,500.

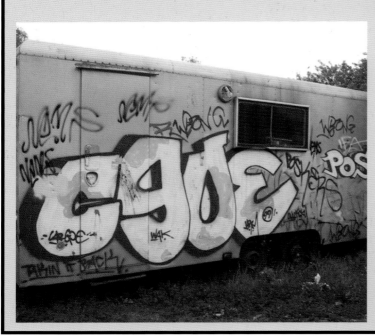

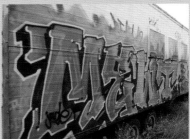

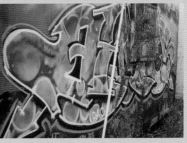

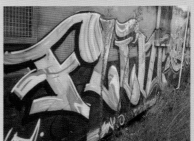

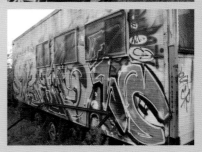

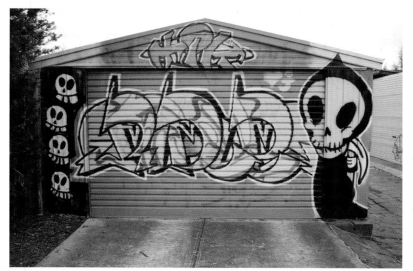

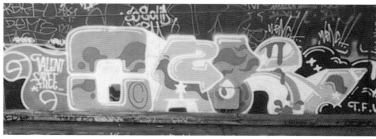

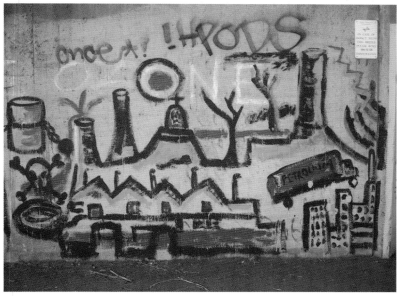

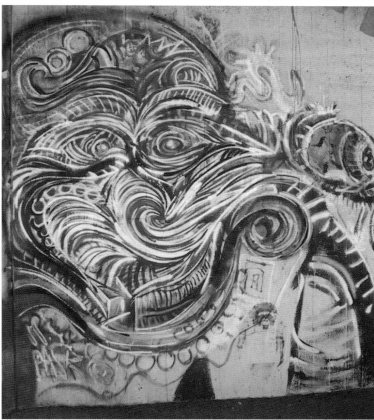

# Talent and diversity

This page illustrates the quality and diversity of the work that can be seen in a city bursting with fantastic artists. The top left hand 'Dr Death' piece is a garage in Northcote. Next to it is a mural from the bridge outside South Yarra Station, which reminds me of modern art paintings I saw in London as a child.

The image at bottom left is reminiscent of L S Lowry's matchstick men and dogs, while that at bottom right shares similarities with Vincent van Gogh, although this piece looks as if the artist was even more insane. Both of these pieces are on the underpass of a road bridge between Richmond and South Yarra Stations.

'Plain walls' are not regarded by writers as 'clean' or 'pristine' or as surfaces not to be written on. Instead, plain or cleaned walls are seen as 'negative' or 'blank'.

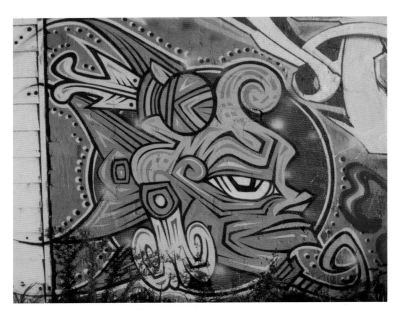 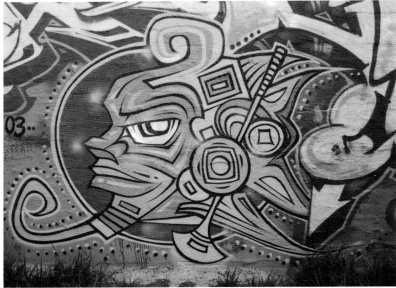

The artist who created these murals is arguably the most recognisable, talented and well known in Melbourne. Phibs' works are mostly legal these days, and adorn the walls of Melbourne shopping centres, tram stops, and city streets. His work is worth watching out for. He paints free hand, and his skill with a spray can is self evident. As an individual he is the most unassuming, modest and sincere character out there.

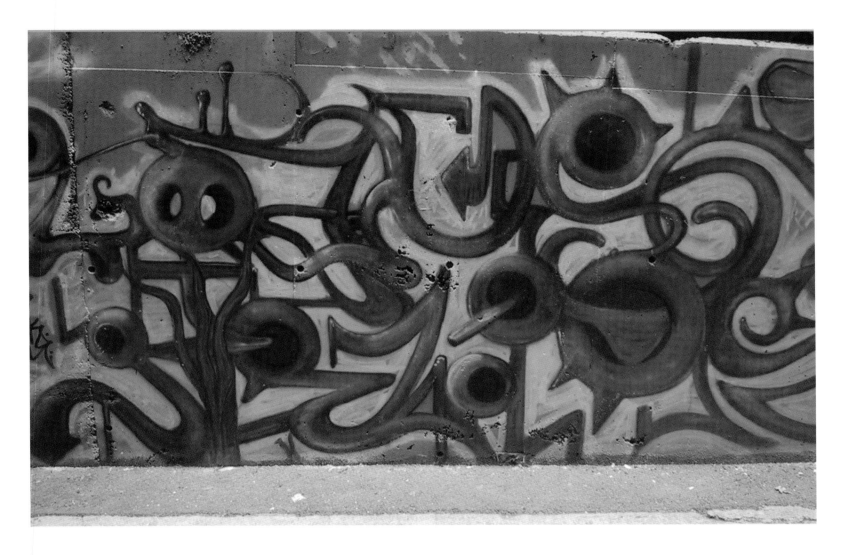

# Paint, paint and more paint covers the walls

Given the amount of time and effort that goes into creating large pieces, it is not surprising that writers do not forget about a piece once it is completed. Some visit it repeatedly in order to take pleasure in looking at the finished work, but others go back to make sure that it is still in good condition, or that it looks as good as they remember.

Although artists are aware that their work is illegal and likely to be removed, they are still terribly frustrated and disappointed when they find that their work has disappeared. They regard railway lines especially as their personal exhibition space, and they live in hope that their work will be considered good enough to be left alone, a hope nurtured by the fact that many works are left standing.

A survey conducted by KESAB in South Australia found that "rapid response removal strategies do not deter writers from continuing to piece. In fact, one writer commented that if one of his pieces is 'buffed', he will replace it with a tag as punishment for cleaning the piece, since he feels that a tag looks worse than the piece which was removed."

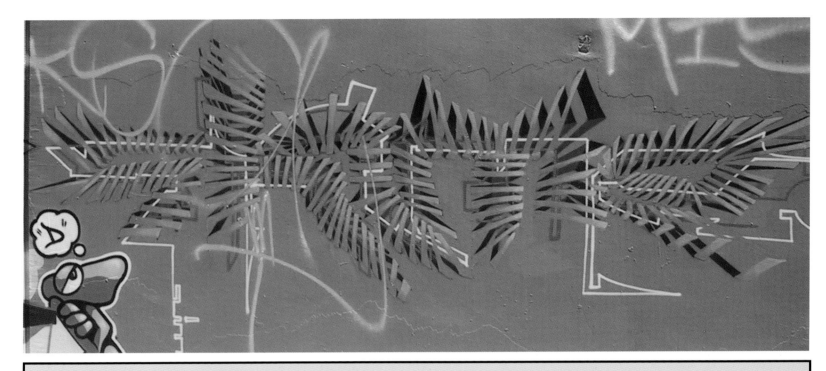

Most piecers regard the use of stencils for creating a piece as a cop out, and have a complete lack of respect for the technique, believing that if the artist resorts to stencils it means they were not good enough to complete the piece freehand. Interestingly, though, the crews in Melbourne often comprise a mix of different graffiti stylists: stuckists, taggers, throw-up specialists, and so on.

It is hard to imagine how artists can complete some of the more intricate pieces without resorting to the use of something to assist with the straight lines. The piece above by Shime, which is likely to have been done fully freehand, has to be close to the ultimate masterpiece.

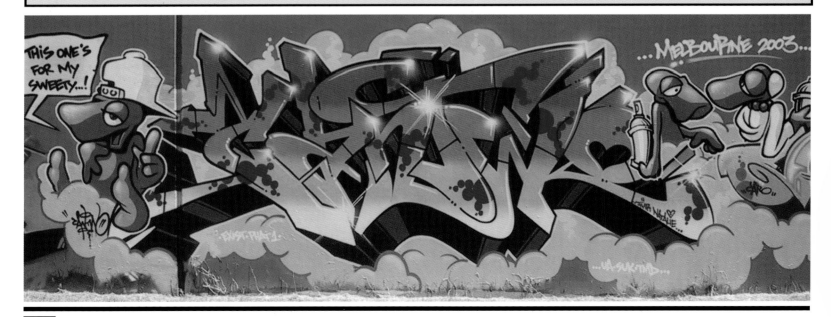

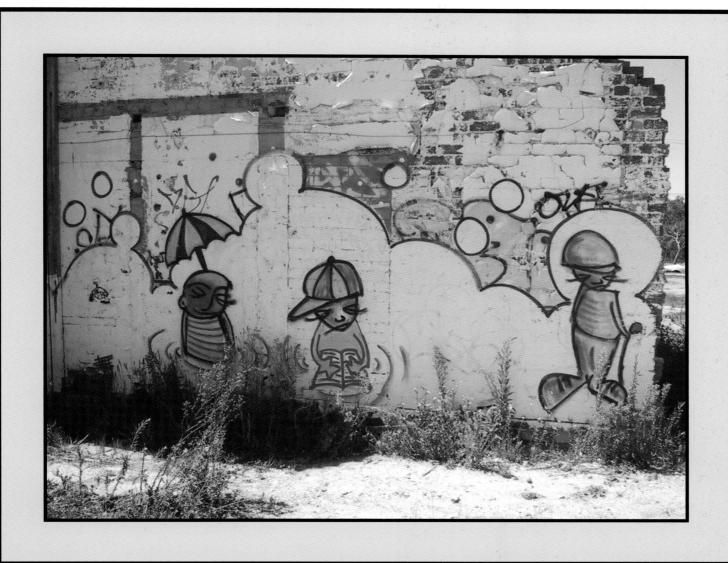

Completed by two brothers, this piece in Brunswick East is supremely peaceful. Created on an ideal backdrop for the design, it makes you feel inclined to drift off and daydream.

# Cathartic graffiti

Quiet, soft and strong, MIC is an enigma. Everyone in the world of street art, graffers and mimetic artists alike, respects him. Despite his quiet charisma, he would have us believe he is a disturbed character, and sometimes there are indeed shades of darkness evident in his personality. He is reticent, but when he is persuaded to speak he is articulate and highly knowledgeable. There is almost nothing and no-one he does not know in the Melbourne graffiti scene (a godsend for me while I was writing this book).

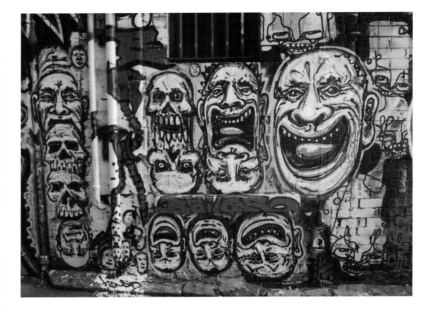

His take on life seems to be to live it, to get up and get out there, rather than sitting back on his haunches. His world and his work sits on the edge of the graffiti world, not properly in the realm of graff, nor in the mimetic realm of stickers and stencils. MIC's productivity can only be truly appreciated when moving around Melbourne by foot or by train. You don't have to look hard, but you must make some initial effort to notice his work. Once you have seen one piece, his work suddenly leaps out at you everywhere.

MIC has painted his faces for seven years. He has no idea how many, they get painted over quickly, so it is impossible to be sure. But given that he tries to paint every day and that on a conservative estimate his weekly output is typically about ten faces, his annual average will top 500.

**Mic's photographs have been intentionally blurred.**

So why the fixation on faces? They are a means of exorcising his demons. He has intense emotional highs and lows, and, like other people, uses his hobby to release tension and maintain a stable emotional balance. The results are incredibly expressive.

He is driven to perfect the depiction of human expressions, and has a macabre fascination with skeletons and skeletal tissue. The faces are often moody and contorted, but MIC aims to represent a range of expressions, from grimaces to smiles.

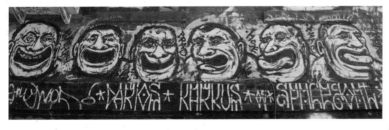

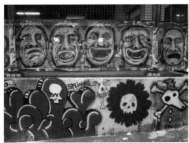

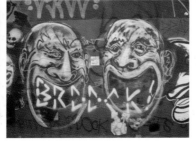

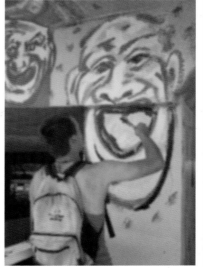

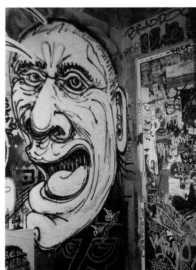

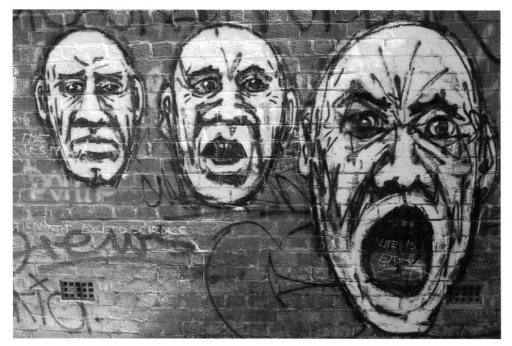

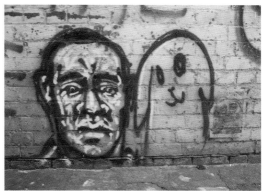

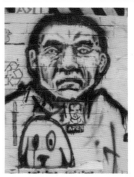

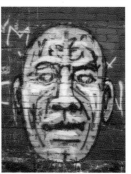

MIC's technique is intrinsically tied to his refusal to be a consumer. He believes adamantly in recycling, and spends his time trawling bins and rail tracks for materials. He collects paint, photos and other assorted recyclables daily. His collection now includes hundreds of cans of spray paint collected trackside where other writers abandon them to avoid getting caught, and hundreds of tins of standard paint. The faces themselves can be painted with anything: sponges, for example, work well as they hold the paint; a moccasin turned inside out serves the same purpose. The brush could be a toilet brush or a plastic bag. He manipulates the world around him but doesn't engage in the cycle of consumption to do so.

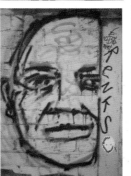

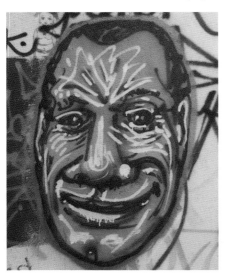

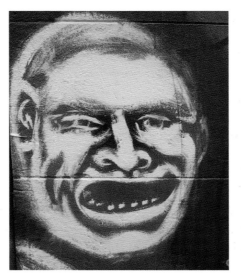

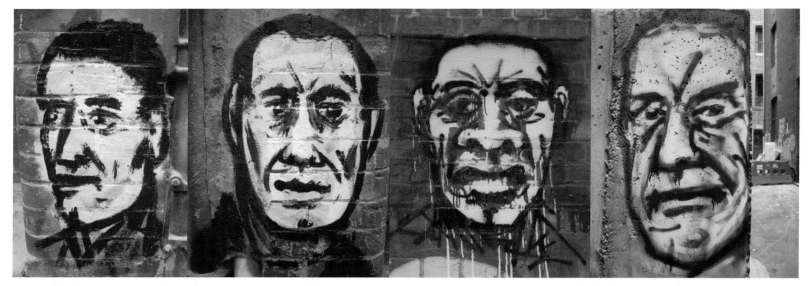

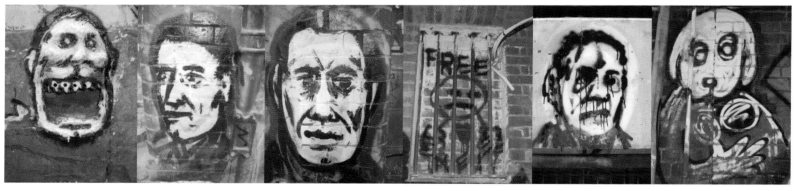

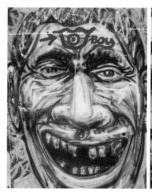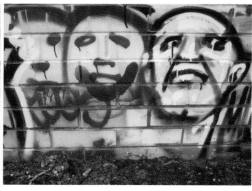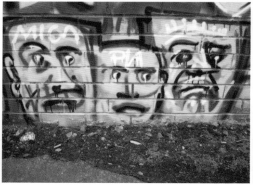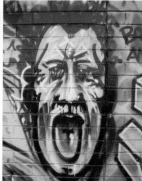

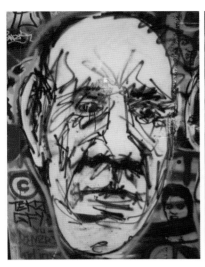

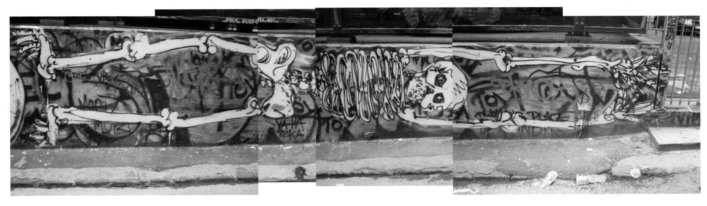

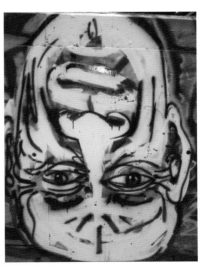

A response to MIC's faces was beautifully expressed by a young girl walking out of a city shop with her mother. She immediately noticed the face and its floppy-eared dog companion and exclaimed "nice doggy ... scary monster" before running to catch up with her mum.

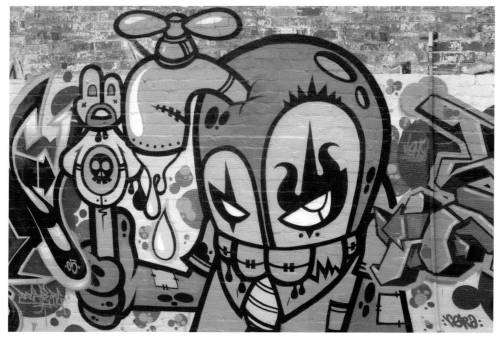

# 05 - Reka's purple patch

Still a young man yet to graduate from university, Reka initiated himself into the world of graff years ago. Typically unstereotypical in that he is from an affluent Melbourne suburb, his development as a writer is more characteristic of a graffiti artist. He began by tagging, although Reka has been his name only for the last seven years, and then moved into characters. The characters he now paints as murals on the railway lines have only been in his designs for the last three years.

He has been inspired by cartoons, most notably *anime* and the classic *Ren and Stimpy*. Cartoon characters are generally two-dimensional silhouettes, with strong colours and outlines. They lend themselves well to black and white reproductions, important in creating renderings quickly as graffers usually need to do. Reka's characters have a clean-cut, brightly coloured and boldly outlined style that is indicative of both his personal traits and his inspirations. Working closely with Sync and Phibs, he has created many hand-drawn montages of creatures in black ink on white paper pasted up with wallpaper glue on city surfaces.

Like most street art characters, Reka's are not cute and cuddly. Instead they take on a darker, almost demonic, quality. The cuddly bear is slashed and burned and presented as if it had walked off of an X-Box set.

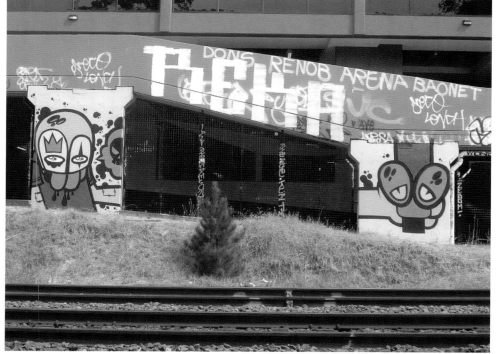

Reka always thinks about the environment in which his characters, and even his tags, will be placed. The characters in particular will use their environs, climbing off of a window ledge, for instance, or peeking around the corner of a building. "Some areas need rescuing", he says. Like many writers, he feels duty bound to brighten things up or replace low-quality graffiti.

He is driven by more than a desire to stamp his mark on the world. He also cares about style, turning heads and getting respect for doing something different – using characters as pieces. Reka's work is and always will be high quality. Of course "knowing that I've been there" is still important. So, like many artists, Reka often paints reasonably close to home, although it is always wise to keep a certain distance.

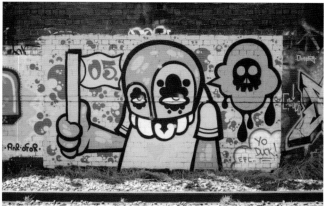

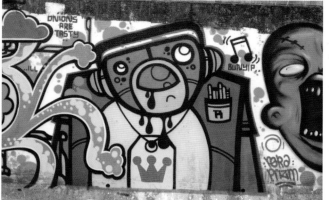

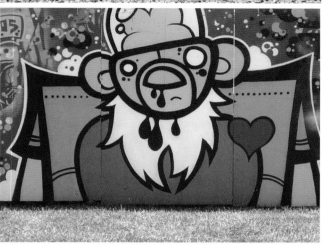

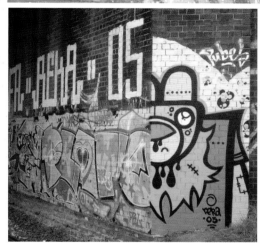

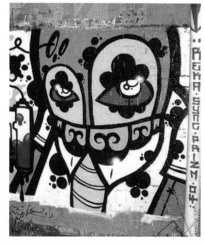

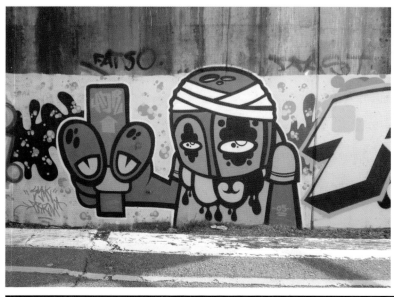

Reka is calm and confident in who he is and what he wants. He has a hunger for discovery, takes things in his stride and enjoys the moment, each and every one. Ironically, for a graffer, he is also risk averse.

While others have gone into film, regular jobs or just faded away. Reka wants to make toys, building on the name he is developing. To do this means he needs to be seen more, and that means you can expect to see a lot more of his signature-style characters along the lines.

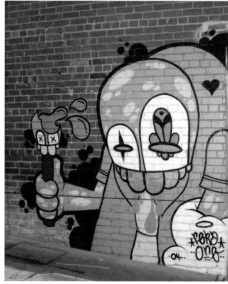

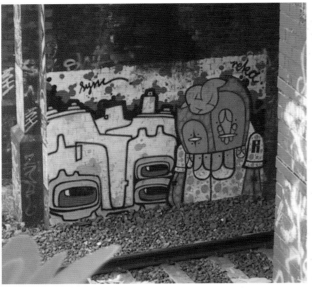

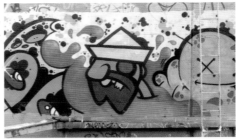

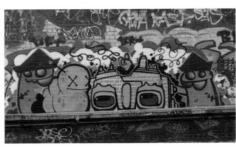

# Collaborations

Street artists often in groups or crews. Doing so reduces the risk of being caught by both authorities and work rival crews. More people means extra spray cans can be carried and the workload can be shared, so pieces can be completed more quickly. This might mean finishing in one hit a piece that would take an individual artist several nights to complete. Companionship can also be important. Crews are different from gangs, in that their primary interest is graffiti rather than violence over erritory.

Crew names are entertaining in themselves. Some are macho, some indicate the crew's modus operandi, others are symbolic of how the group want to be perceived by other crews.

For example, the messages sent by the crew names Crime Does Pay (CDP) and Kick Some Arse (KSA) are pretty straightforward. It is wise not to overwrite work by these crews.

Everfresh and Thick as Blood (TAB) pride themselves respectively on their constant innovation and being about 'art over attitude'.

The acronyms of some crews have many interpretations. SDM is respectively Sleep Deprived Maniacs, So Damn Mad and Swet Da Met, while TGC, one of Melbourne's older crews, can be either The Graffiti Connection or Toys Get Crushed.

The pieces shown here do not necessarily represent the work of specific crews, but rather collaborative sessions between a select group of highly respected artists, Prism, Sync and Reka. The innovations they have brought to trackside pieces have raised the profile of graffiti and have the city talking. This collaborative work adds another dimension to a city already flooded with talent.

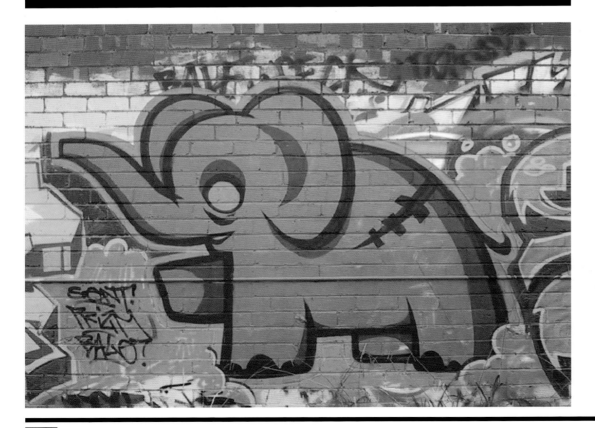

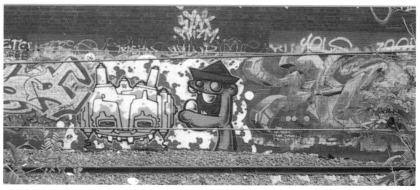

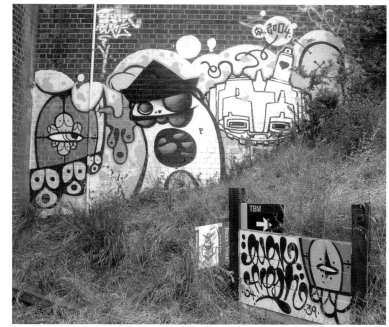

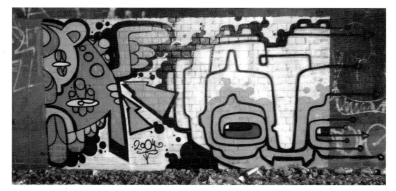

# The whacky, whacky  world of the street art puppeteer

Ghostpatrol is a softly spoken, quietly disarming and engaging street artist. His shy, almost timid manner belies his burgeoning reputation as a major street art cartoonist and sketcher. He is sought after by commercial and artistic companies, as well as local and international street artists at all stages of their career.

He has moved on from his initial forays into the world of stickers and paste-ups, through a dabble with stencilling and spray can art, to a point where his reputation will build him a career doing the thing he loves most –creating pen and ink drawings. His line drawings of characters take you into the darkened, moody recesses of his mind, where his personal gremlins and wild things roam.

Ghostpatrol's interest in street art started at university. His closest friends, like him, had little interest in their studies and they found other ways to spend their time – making stickers, taking photos, mucking around. Some of the original stickers he and his friends created can still be seen, five years on. For example, at the centre of the company logo on a Target store in Sydney a small sticker with a lion warns: "Animals talking behind you when your back is turned".

Not content with just mucking around, Ghostpatrol intentionally began to develop his hobby into something more meaningful and long-lasting. With a head full of ideas, he began to create his art, and he hit the streets to  develop his skills.

He moved on to dabble with stencils after finding a representation of the popular computer game Frogger stencilled across a major junction, with an in-scale 'splat' at the centre of the road. The frog itself was pixelated to retain the computer graphics imagery. The flirtation with stencils was brief, before he turned his attention to developing his characters' personalities and creating storylines for them, which were serialised, magazine style, on the city's streets. He has transformed some of his characters into three-dimensional effigies (pictured below)

Ghostpatrol's success is ultimately due to his innate talents and exceptional imagination, but like many people, the driving force behind him is his partner. His own words sum up his belief that: **"the truth is that without her, anything I do simply wouldn't be happening"**.

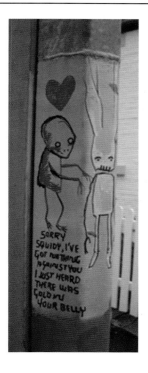
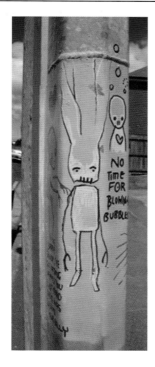
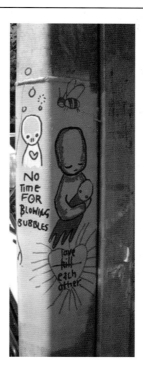

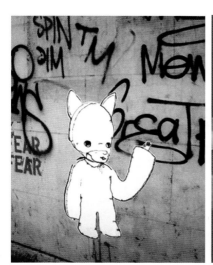

Much of Ghostpatrol's success is due to what could be now be seen as branding, although he did not perceive it as such at the time. All stickers went out with his email address as a means of informally collecting feedback. The stylised and recognisable stickers challenged viewers to an urban game of hide and seek.

The development of his characters, and subsequent publication of these characters both online and through well-placed street stickers and paste-ups, provided the opportunity to nurture and develop his creativity.

Joining Stencil Revolution was another factor in his success, and a major turning point in his life. The Stencil Revolution website allowed him to receive feedback on his own work and view work by like-minded artists worldwide, allowing his creativity to develop, perhaps faster than it otherwise would have. Stencil Revolution boasts around ten thousand members, and membership continues to climb.

Stencil Revolution has also contributed to an extensive social network. When he travels he is offered assistance by aspiring and successful artists who all want to work with him. Such artists constantly send him examples of their work. Conversely, Australian and European artists paste his characters in their hometowns. This network provides untold opportunities to learn and share, enhance his artistry, and increase his productivity.

He is ambitious and constantly busy, and you can't help but feel that it is only a matter of time before he successfully bursts onto our television or cinema screens with some whacky and wild street-developed characters.

But Ghostpatrol is not creating art for profit or fame, purely out of a love of creating, and the single biggest reward, peer recognition. Many artists get the biggest satisfaction from someone they admire getting in touch after they saw their name scratched on a table, or someone they never met pasting a sticker with a direct greeting next to one of theirs.

Creating art for the street allows Ghostpatrol to enjoy his creativity without taking himself too seriously. It enables him to express his ideas without the need to gain recognition through, for example, formal art gallery exhibitions. Less fretting, more actual doing.

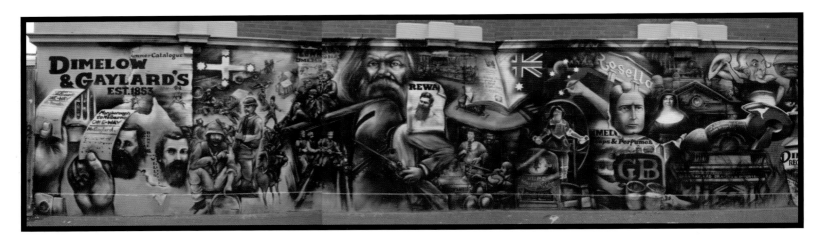

# Retail colossus meets graff writer - an Aussie icon turns 150

Dimmeys is more than a shop. It has been a Melbourne icon for 150 years, part of Melbourne's folklore. Its long illustrious history is now displayed in arguably the most elaborate street mural in Australia.

Painting a mural on its wall in Green Street, Richmond was Dimmeys' idea. Fed up with having its walls constantly tagged, and concerned about the negative effect that graffiti was having on the store's image and the neighbourhood, Dimmeys decided to do something to counteract unwanted graffiti. So the concept of displaying the store's history along the wall was born.

As Dimmeys was composing a brief to put out to tender for the completion of a historical mural on their Green Street wall, Hayden Dewar, a local graffiti writer, walked into the Richmond store in search of a legal wall. The response from the manager in the store was "it's a bloody weird subculture", but fortunately for Dimmeys and Hayden, the manager contacted head office where the ball was already rolling. Hayden got a far better deal than just a wall – he got a commission to paint Dimmeys' history. So a retail icon and a graffiti artist came together to achieve their goals.

Hayden's ten-year focus on graff and his own artistic development has culminated in this mural, which has provided him with an unparalleled opportunity to demonstrate his skills.

Hailing from the Melbourne suburb of Belgrave, Hayden is a graduate of Swinburne high school, which has spewed forth many of Melbourne's key graffiti writers. He has no professional or academic artistic training, having had to relinquish a course on illustration due to financial constraints. He began his romance with graff in 1996 as a bomber by the name of Brycks. (This name was short-lived as it was too close to another local writer's tag, an offence for which he got a good kicking.) With Plea, Grate and Gyro he formed the Thick as Blood crew of artists who are more into art than attitude. While Hayden sees bombing as a pure form of graffiti, his preference is for drawing characters.

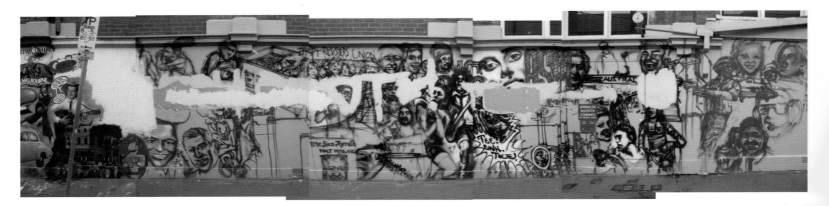

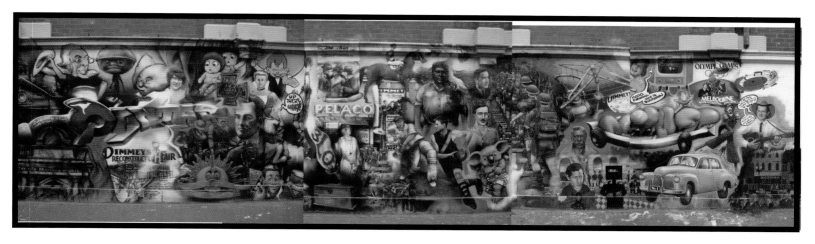

The first inspiration he remembers was the image of Eddie on Iron Maiden's album covers. More recently his preference has been to bring realism and depth into his characters, and his current inspirations span from the Italian masters Michelangelo and Da Vinci to key graff writers Hex (US) and Nosm (Europe).

He tackled this monster of a mural with a quiet resolve, and although the piece took longer than he expected, by several months, the personal pride he gained drove him to completion.

His response to the brief was to select important historical touch points. The final proposal presented to Dimmeys was a photomontage, closely focused on the history of Dimmeys, Richmond, and Victoria, as well as significant events in Australia between 1853 and 2003. In the meantime, with little knowledge of Australian or Dimmeys' history, Hayden had to embark on some extensive research. One of the richest sources was the archive of advertisements and clippings at Dimmeys head office.

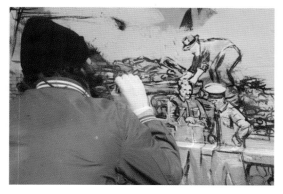

The piece is already a success. Those writers who tagged it (most notably Drastic with "you selfish runt") are long gone and unlikely to return. The work is respected by writers and the public alike. Some might get close to painting over it, but who could bring themselves to go through with it?

The mural is a triumph for Dimmeys, Hayden, street art and the people who pass by and stop to catch a glimpse of history. Graffiti is usually removed, buffed, scraped off or painted over, but this piece of street art will last.

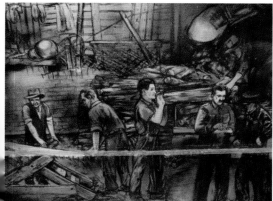

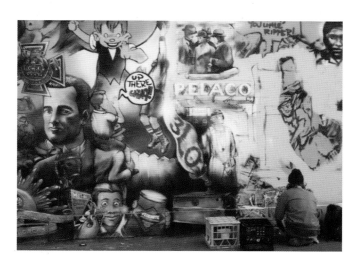

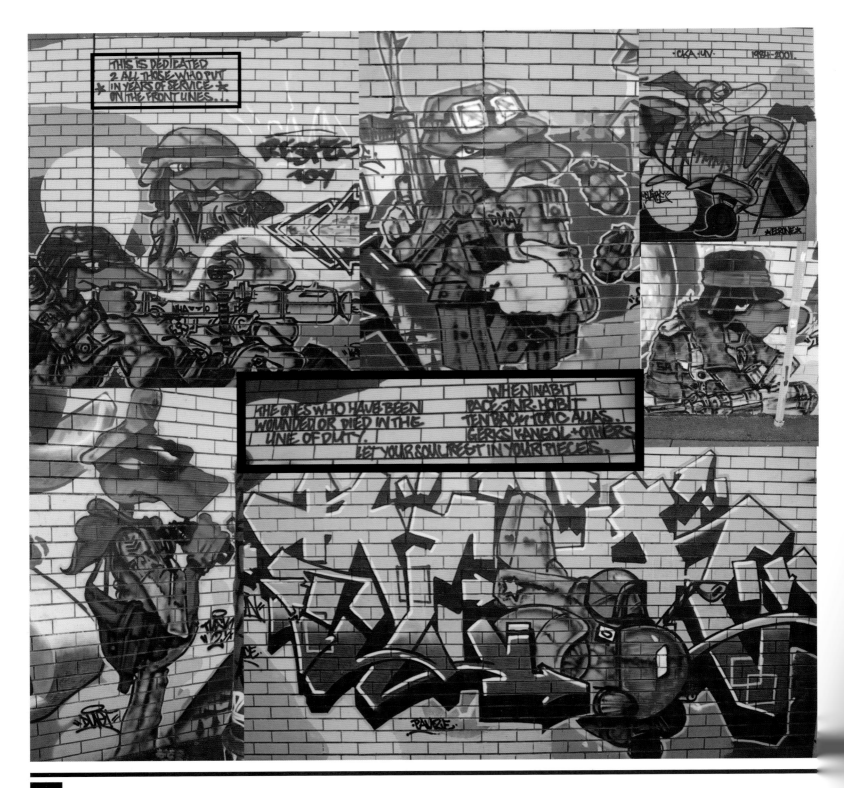

# 3D Graffiti

Sculpture is an anomaly in the street art landscape. It takes time to create and occupies three-dimensional spaces rather than two-dimensional surfaces. Sculpting in public increases the time required to complete the work and thus raises the stakes for the artist.

There are ways, however, to install large sculptures in public spaces without getting caught. One group specialises in carvings. They dress up like council workers to install them in the middle of the day, usually on major intersections. No-one bats an eyelid.

**The faces shown here are created from materials left on building sites.**

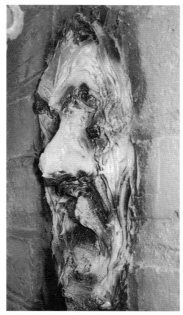

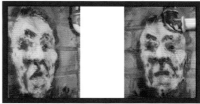

The carving shown below at Richmond Station would have been a risky labour of love, but has the benefit of being relatively permanent compared to other street art forms.

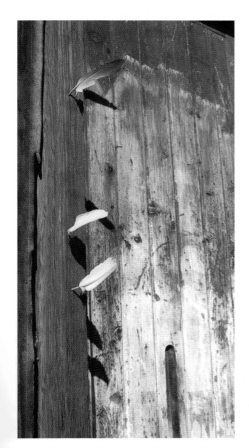

'Merge' was created over a two-month period in three sessions, starting in December 2004. This period coincided with the tsunami in the Indian Ocean, something it closely resembles. Merge was completed using paint fired from fire-extinguishers. The paint was applied in layers, leaving sufficient time for each layer to dry before revisiting the site to add the next set of colours. This also allowed blisters, that had formed because air was hand-pumped into the extinguishers, to heal.

The effect of this art is spectacular, the scale huge, and the technique straightforward. A fire extinguisher (about ten were used for this project) holds close to ten litres of water-diluted paint, and empties in a matter of seconds. In terms of the actual application of paint, the project took only minutes.

The artist is responsible for a number of the Jackson Pollock–like backdrops appearing earlier in this book.

# Merge - an art project

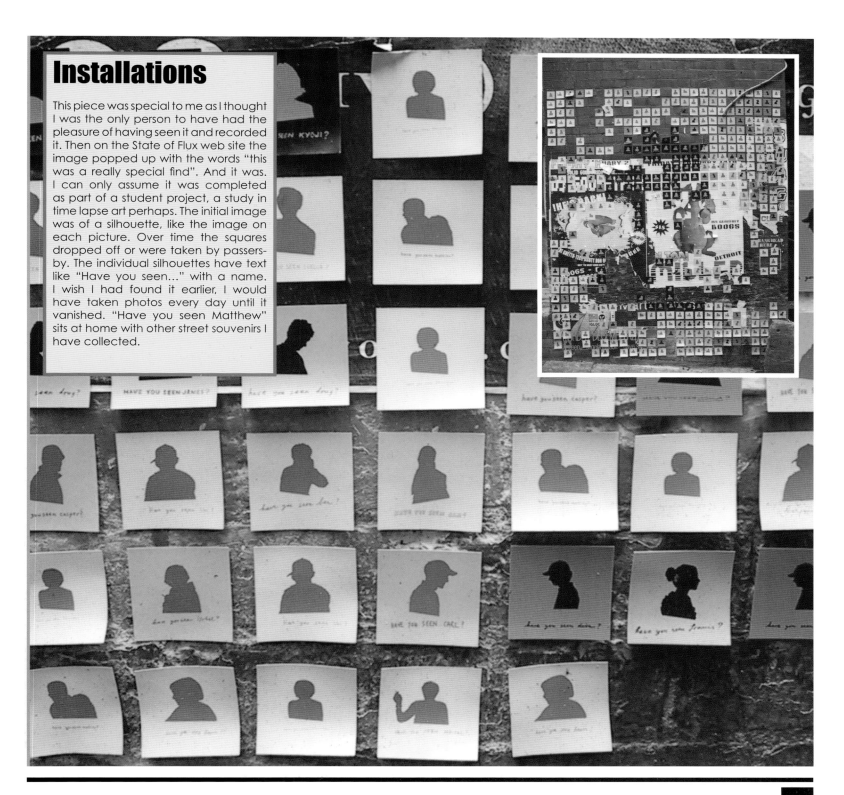

# Installations

This piece was special to me as I thought I was the only person to have had the pleasure of having seen it and recorded it. Then on the State of Flux web site the image popped up with the words "this was a really special find". And it was. I can only assume it was completed as part of a student project, a study in time lapse art perhaps. The initial image was of a silhouette, like the image on each picture. Over time the squares dropped off or were taken by passers-by. The individual silhouettes have text like "Have you seen..." with a name. I wish I had found it earlier, I would have taken photos every day until it vanished. "Have you seen Matthew" sits at home with other street souvenirs I have collected.

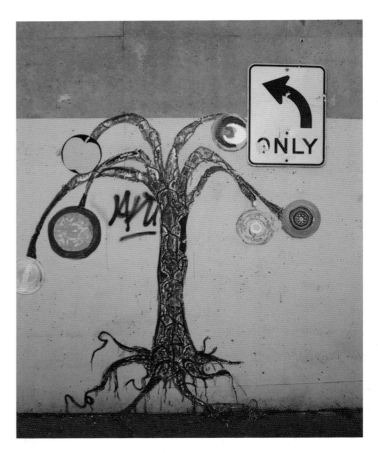

# Art students out on the town

Many of Melbourne's tertiary education institutions offer art and design courses, and each seems to give students a chance to create something public as a field project. This means the public gets to experience the creative energies of a group of emerging artists as they are let loose on the city. Like students, student art can, at times, be controversial. Most of the pieces pictured on this page have the mark of student art.

The image right, however, is of a different, but just as interesting, ilk. Taken at the Melbourne Zoo, this photo captures young children's pictures of elephants. Perhaps some of them were drawn by members of a future generation of Melbourne's street artists.

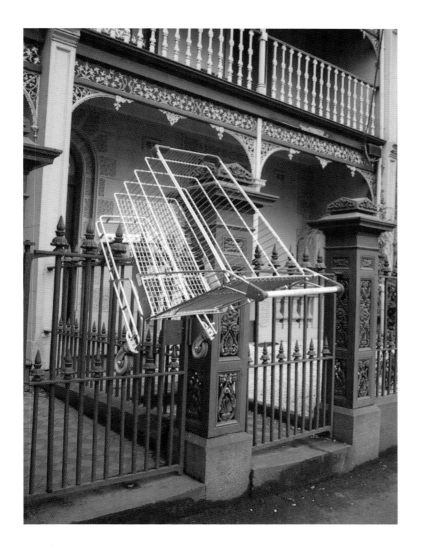

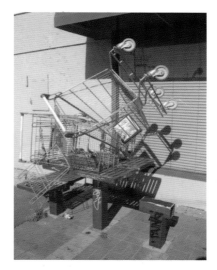

# Trolley art - eyesore or icon?

Why is this form of street art included in this book? It wasn't going to be until I noticed a disassembled trolley hanging like some sort of giant pendulum from a tree in High Street, Northcote. Trolleys lend themselves to vandalism and the outcomes are often artistic. The trolley plonked onto railings was probably the result of a late night drinking session. The lines combined with the wrought iron railings and trellises of the building are visually striking.

Unfortunately, though, trolley vandalism is often associated with violence. The bars are stamped out and then used as weapons in gang fights. Such violence is rarely the province of street artists.

Street artists often inflate balloons with excess paints and target advertising hoardings with the intent of disfiguring the advert or providing some additional effect. In this case, the paint bomb missed the advert completely, splattering paint mostly over the framework.

# Advertising versus vandalism

Mimicking the look and feel of the target advertisement, a subvertisement alters or replaces the text and/or image of the original ad to get its own message across. Take for example the graffiti that appeared in the run up to Australia's 2004 federal election: "Howard versus Latham – Whoever wins we lose", a variant of the ads promoting the *Alien versus Predator* film. While subvertising often has a charged message to convey, sometimes it is nothing more than a simple joke. Often a second glance is required for the change to become noticeable and the humour to be appreciated.

Subvertising can actually extend the reach and strength of the original ad's corporate message, as paradoxically it is still present within a subvertisement. Sometimes the subvertisement is not even designed to target the original advertiser. In the 2002 McDonald's subvert "Make French Fries not War", for example, the company is not the target of the subvertising, George Bush and his cronies are.

We are constantly exposed to corporate adverts and we often unthinkingly use their slogans and jingles in everyday life. Those slogans and jingles are designed to be recognisable and catchy, so adapting them for our own everyday purposes is almost inevitable. Street artists take this one step further.

It can be argued that graffiti is vandalising public space. If so then one could argue that the same is true of advertising. Both infringe on public space, but the public is not consulted about placement or content. In fact, advertising is less palatable than graffiti to many people. While researching this book, most people I spoke to rated advertising as the most despised form of vandalism because it is worse than graffiti in terms of invading one's personal space. They also described advertising as often being childish, irresponsible and frivolous.

Perhaps because of this dislike, advertisements can be targets for graffitists.

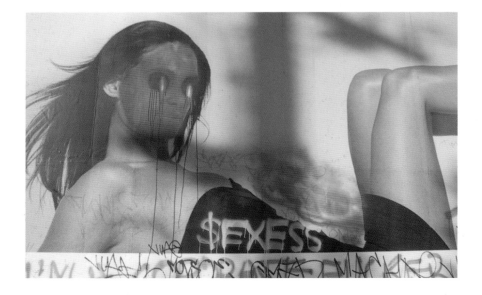

Advertisements aren't the only familiar signs to be modified. The "Form 1 Planet" road sign pictured here is reminiscent of Richard Tipping's book Signs of Australia in which he illustrated modified road signs, famously with an "Airpoet" sign pointing up to the sky.

# The man in the street makes his own contributions

If asserting one's identity is as important to everyone as it is to the street artist, how does the average person impose their identity on the street without choosing to become a graffitist?

We dress and behave in a particular ways, but we also leave more permanent marks. Some examples are shown on this page. We personalise our space through many different avenues. We might, for example, decorate our properties by choosing and displaying a name for our house, creating a decorative house number, mounting garish Christmas displays, or plonking down strange adornments like the petrol pumps you occasionally see in country Victoria.

Another key way that we impose our personalities onto the street is through customising our vehicles. Some people decorate their cars with fluffy dice. One car I saw had an array of plastic pigs positioned around the centre of the dashboard (the number plate read "ThePig",

so it seemed apt). Personalised number plates reflect a person's character and how they perceive themselves. I saw DAWOLF, IXCITU and MADJOE on cars stereotypically associated with hoons. Cars at the luxury end of the market tend to having personalised plates with a number, like a place marker in society: 300GUM, MrMr01 or HENRY0. Whether the owner wants to appear cuddly with "Peaches" or impart their sense of humour with "Gdfella" or "Bouzon" the choice tells you something about the nature of the owner, much like graffiti tells you about the nature of the writer.

The piece shown at bottom right is more unusual, and something almost from an age gone by. It is a collecting post for footy stickers. School children paste up their surplus stickers, and engage in an anonymous trading game. I found this under a railway bridge in Caulfield. It is now covered up by graffiti paste-ups.

# Pictography - I

Each image is allocated a number in a clockwise fashion for each page starting from the top left hand corner, the artist's name where known and in the Page by Page bibliography the location and the date it was taken.

## Pictographic Key

| | | | |
|---|---|---|---|
| G | GRAFFITI | T | TAGGING |
| Sc | SCULPTURE | Pl | PLAQUE |
| M | MURAL | TU | THROW-UPS |
| St | STICKER | Po | POSTER |
| O | OTHER | V | VANDALISM |
| Stu | STUDENT | S | STENCIL |
| Pg | PERSONALISING | | |
| Su | SUBVERT | | |
| Pi | PIECE | | |

# Pictography - II

## Bibliography: Page by Page

2 **ARYZE** North Melbourne May-04

3 **FORM** Hosier Ln Sep-04

4.01 **UNKNOWN** Swan St Apr-03, 4.02 South Yarra Sep-02, 4.03 **DAMMIT, NEXT** Johnson St May-02, 4.04 **ROPAR** Little Lonsdale St Aug-02, 4.05 **UNKNOWN** Johnson St Apr-03, 4.06 **DLUX** Hosier Ln Aug-02

5.01 **SHINE** Bourke St Mar-03, 5.02 **UNKNOWN** Unknown Mar-04

, 6.01 **ROFL** Richmond Stn Nov-04, 6.02 **ROFL** Richmond Stn Nov-04, 6.03 Richmond Stn Dec-04, 6.04 **UNKNOWN** Port Melbourne May-05, 6.05 **RENKS** CBD Jan-05, 6.06 **NEW2** Port Melbourne May-05, 6.07 **UNKNOWN** Port Melbourne May-05, 6.08 **DELETE** Port Melbourne May-05, 6.09 **UNKNOWN** Port Melbourne May-05, 6.10, CBD Sep-04

7.01 **UNKNOWN**, Little Collins St, Mar-03, 7.02, **PSALM**, Melbourne, Nov-04, 7.03, Melbourne, Nov-04, 7.04 **UNKNOWN**, St Kilda Jn, Apr-05, 7.05 **UNKNOWN**, St Kilda Jn, Apr-05, 7.06 **MIC**, Hosier Ln, Jun-05, 7.07, **PSALM**, Melbourne, Nov-04

8.01 **DEST** St Kilda Jn Apr-04, 8.02 **UNKNOWN** Port Melbourne Jun-05, 8.03 CBD Jun-05, 8.04

Duckboard Pl Jun-05, 8.05 CBD Jun-05, 8.06 **Various** Hosier Ln Jun-05, 8.07 **HAILLE** Duckboard Pl Jun-05

9.01 **Various** St Kilda Jn Apr-04, 9.02 **FERS** Little Collins St Jul-03, 9.03 Little Collins St Jul-03

10.01 **Various** Centre Pl May-04, 10.02 Centre Pl May-04

11.01 **UNKNOWN** Northcote Mar-03, 11.02 Coburg Sep-03, 11.03 **PSALM** Northcote Mar-03, 11.04 **STANLEY** Clifton Hill Mar-03, 11.05 **UNKNOWN** Fitzroy Jun-03, 11.06 **HaHa** Carlton May-03, 11.07 **UNKNOWN** Flinders Ln Sep-04, 11.08 Richmond Jun-03, 11.09 Hosier Ln Sep-04, 11.10, **FDP** Clarendon St Jul-04, 11.11 **UNKNOWN** Little Lonsdale St Sep-04, 11.12 **CRIME DOES PAY** Sep-04, 11.13, 11.14 **MONKEY** Caledonian Ln Jul-04

12.01 **BONES** Swan St Feb-05, 12.02 **UNKNOWN** Hosier Ln Jun-05, 12.03 Abbotsford Feb-05, 12.04 Brunswick St Feb-05

13.01 **CITYLIGHTS** Hosier Ln Apr-04, 13.02 **UNKNOWN** Unknown Nov-02, 13.03 Unknown Jan-02, 13.04 Yarra Rail Bridge Feb-05

14.01 **HAHA** Hosier Ln Sep-04, 14.02 **UNKNOWN** Fitzroy Jun-04, 14.03 **OPTIC** Canada Ln May-04, 14.04 **MEEK** Canada Ln Jul-03

15 Sketches by Ghostpatrol

16.01 **UNKNOWN** Fitzroy Apr-03, 16.02 Fitzroy Apr-03, 16.03 Swanson St Jul-03, 16.04 **ASLAN** Hosier Ln Nov-03

17.01 **BANKSY** London Nov-02, 17.02 London Jan-03, 17.03 Richmond Apr-03, 17.04 **BERT** Bourke St Jul-03, 17.05 **SADE, GERM, HPOD, ZIMA** Burnley Stn Jun-03

18.01 **UNKNOWN** Little Lonsdale St Apr-04, 18.02 **FUISM** Hosier Ln Apr-04, 18.03 **JADE** Windsor Jul-04, 18.04 **UNKNOWN** Richmond Jan-03, 18.05 **Unknown** Carlton May-03, 18.06 **SIXTEN** Smith St Apr-03, 18.07 **UNKNOWN** Carlton May-03, 18.08 Carlton May-03

19.01 **MONKEY** Stewart St Mar-04, 19.02 Little Lonsdale St Mar-04, 19.03 **CIVIL** Canada Ln May-03, 19.04 **HAHA** A'Beckett St Feb-04, 19.05 **CIVIL** Canada Ln May-03, 19.06 **UNKNOWN** Yarra Trail Jul-03

20.01 **UNKNOWN** Hosier Ln Oct-03, 20.02 **UNKNOWN** Fitzroy Aug-02, 20.03 **MEEK** Yarra Trail Sep-03, 20.04 **MEEK** Yarra Trail Sep-03, 20.05 **UNKNOWN** Unknown Feb-03, 20.06 Fitzroy Aug-02, 20.07 **UNKNOWN** Yarra Trail Ln Aug-03

21.01 **DLUX** Healeys Ln Jul-03, 21.02 **UNKNOWN** Northcote Jul-03, 21.03 Richmond Jul-03, 21.04 Unknown Feb-03, 21.05 **PLUSH** Carlton May-03, 21.06 **DLUX** Little Lonsdale St Feb-03, 21.07 **UNKNOWN** Fitzroy Aug-02, 21.08 **OPTIC** Brunswick Nov-03, 21.09 **UNKNOWN** Carlton Jun-03, 21.10,

# Pictography - III

**DOMINIC ALLEN** Richmond Dec-03, 21.11 **BANKSY** Unknown Feb-03, 21.12 **SATTA** Little Bourke St Dec-03, 21.13 **MEEK** Elsternwick Jul-03

22.01 **UNKNOWN** Centre Pl Aug-02, 22.02 **ASLAN** Hosier Ln Oct-03, 22.03 **RAIFI** Corporation Ln Mar-03, 22.04 **ASLAN** Carlton May-03, 22.05 **UNKNOWN** Elizabeth St Aug-02, 22.06 **RAIFI** Centre Pl Aug-02, 22.07 **E3** Melbourne Suburbs Jul-03, 22.08 **UNKNOWN** Centre Pl Aug-02, 22.09 Caulfield East Apr-03

23.01 **PLUSH** Canada Ln May-03, 23.02 **UNKNOWN** Canada Ln May-03, 23.03 **DOLK** Fitzroy Apr-03, 23.04 **UNKNOWN** Melbourne CBD Dec-03, 23.05 **BANKSY** Unknown Dec-02, 23.06 **HAHA** Canada Ln May-03

23.07 **UNKNOWN** Unknown Dec-02, 23.08 **PRISM** Canada Ln May-03, 23.09 **UNKNOWN** Canada Ln May-03, 23.10 **PLUSH** Canada Ln May-03, 23.11 **UNKNOWN** Northcote Mar-03

24.01 **UNKNOWN** Unknown Oct-02, 24.02 Carlton Jan-03, 24.03 **SAFARI** South Yarra Oct-03, 24.04 **UNKNOWN** Centre Pl Sep-02, 24.05 Hosier Ln Feb-03, 24.06 Fitzroy Apr-03, 24.07 **MARINE** Melbourne CBD Feb-03, 24.08 **SHEPERD FAIRY** Melbourne CBD Aug-02, 24.09 **ALAN** Carlton Jun-03, 24.10, **SYNC** Melbourne CBD Mar-04, 24.11 **UNKNOWN** Unknown Feb-02

25.01 **UNKNOWN** Carlton May-03, 25.02 Centre Pl Jan-03, 25.03 Prahran Jan-04, 25.04 Unknown Feb-03, 25.05 **SYNC** Melbourne Suburbs Feb-03, 25.06 **UNKNOWN** Unknown Feb-03, 25.07 **SYNC** Melbourne Suburbs Jul-03, 25.08 **UNKNOWN** Northcote Mar-03, 25.09 **SYNC** Melbourne Suburbs Feb-03, 25.10, **UNKNOWN** Unknown Feb-03, 25.11 Unknown Jan-03, 25.12 Carlton May-03, 25.13 Unknown Feb-03, 25.14 Unknown Feb-03, 25.15 Unknown Jan-03

26.01 **DLUX** Carlton Jun-03, 26.02 **UNKNOWN** Unknown Nov-02, 26.03 **DLUX** Carlton Jun-03, 26.04 **WAALLAD** Fitzroy Aug-02, 26.05 **UNKNOWN** Unknown Jan-03

27.01 **HAHA, DEST** Centre Pl May-04

28.01 **MONKEY** Little Lonsdale St Mar-04, 28.02 **UNKNOWN** Collingwood Apr-03, 28.03 Carlton Jun-03, 28.04 Fitzroy Apr-03, 28.05 Melbourne CBD May-03, 28.06 Fitzroy Apr-03, 28.07 Fitzroy Apr-03, 28.08 **MONKEY** Carlton Jul-04, 28.09 **MARINE** Carlton May-03, 28.10, **UNKNOWN** Healeys Ln Jul-04

29.11 **UNKNOWN** Electric Pl Jun-03, 29.12 **PLUSH** Electric Pl Jun-03, 29.01 **CIVIL** Carlton Jun-03, 29.02 Carlton Jun-03, 29.03 Carlton May-03, 29.04 Richmond Apr-03, 29.05 Carlton May-03, 29.06 Carlton May-03, 29.07 Carlton May-03, 29.08 Carlton May-03, 29.09 Melbourne CBD Jul-03

30.01 **RONE** A'Beckett St Feb-04, 30.02 **SIXTEN** Electric Pl Mar-04, 30.03 **SATTA** Little Bourke St Dec-03

31.01 **SIXTEN** Sutherland St Jan-04, 31.02 **SEVENA** Myer Pl Mar-04, 31.03 **BANKSY** Little Collins St Jul-03, 31.04 **RONE** A'Beckett St Jul-03, 31.05 **UNKNOWN** Little Lonsdale St Mar-04, 31.06 **MONKEY** Little LaTrobe St Nov-02, 31.07 **OPTIC** Little LaTrobe St Nov-02

32.01 **UNKOWN** Hosier Ln, Feb-05, 32.02 **UNKNOWN** Collingwood, Apr-04, 32.03 **UNKNOWN** Hosier ln, Oct-04, 32.04 **UNKNOWN** Alexander Pde, Jun-04, 32.05 **UNKNOWN** Curtain St, Mar-04

33.01 **SIXTEN** Victoria Mkt Jul-03, 33.02 Glen Huntley Jul-03,

33.03 **HAHA** Melbourne CBD Mar-04, 33.04 **UNKNOWN** Unknown Feb-03, 33.05 North Melbourne May-04, 33.06 **MONKEY** Melbourne CBD Jul-03, 33.07 **UNKNOWN** Hosier Ln Aug-02, 33.08 **SYNC** Little Bourke St Dec-03, 33.09 **PLUSH** Duckboard Pl Mar-03, 33.10, **SYNC** Melbourne Suburbs Mar-04, 33.11 **UNKNOWN** Fitzroy Aug-02, 33.12 Melbourne CBD Sep-03, 33.13 Fitzroy Nov-03, 33.14 **ROPAR** Little Smith St May-03, 33.15 **SIXTEN** Hosier Ln Jul-03, 33.16 **AVALINE** Electric Ln Mar-04

34.01 **UNKNOWN** Unknown Nov-02, 34.02 Melbourne CBD Feb-03, 34.03 Prahran Jan-04, 34.04 **HAHA** Little Latrobe St Jan-04, 34.05 **BUTTONMONKEY** Centre Pl Aug-02, 34.06 **UNKNOWN** Canada Ln May-03, 34.07 **HAHA** Richmond Feb-03, 34.08 **UNKNOWN** Fitzroy Aug-02, 34.09 Canada Ln May-03, 34.10, **KARISMA** Canada Ln May-03, 34.11 **HAHA** Richmond Feb-03, 34.12 **CIVIL** Carlton May-03, 34.13 **UNKNOWN** Canada Ln May-03, 34.14 **HAHA** Little Latrobe St Jan-04, 34.15 **REKS** Centre Pl Dec-03, 34.16 **UNKNOWN** Canada Ln May-03, 34.17 Fitzroy Mar-03

35.01 **UNKNOWN** Unknown Nov-02, 35.02 Unknown Dec-02, 35.03 Unknown Nov-02, 35.04 Unknown Nov-02, 35.05 Unknown Nov-02, 35.06 Flinders Ln Mar-03, 35.07 Centre Pl Aug-02, 35.08 Unknown Oct-02, 35.09 Unknown Jan-02, 35.10, Fitzroy Jul-03, 35.11 Unknown Oct-02, 35.12 Canada Ln May-03, 35.13 Fitzroy Aug-02, 35.14 Fitzroy Aug-02, 35.15 Brunswick Apr-03, 35.16 Unknown Nov-02, 35.17 Unknown Oct-02, 35.18 Unknown Nov-02, 35.19 Unknown Oct-02, 35.20, Unknown Nov-02, 35.21 Canada Ln May-03

36.01 **ROPAR** Canada Ln May-03, 36.02 **UNKNOWN** Fitzroy Jul-03, 36.03 Richmond Dec-03, 36.04 **SIXTEN** Caulfield Jun-03, 36.05 Unknown Jan-03, 36.06 **SUGARUSHGIRL** Melbourne CBD Aug-03, 36.07 **UNKNOWN** Fitzroy Aug-02, 36.08 Hosier Ln Jul-03, 36.09 Hosier Ln Jul-03, 36.10, **RONE** Little LaTrobe St Jul-03, 36.11 **FUISM** Little Lonsdale St Mar-04, 36.12 **SYNC** Melbourne CBD Jul-03

37.01 **UNKNOWN** Unknown Dec-02, 37.02 **Pound** Fitzroy Aug-03, 37.03 **UNKNOWN** Canada Ln Jun-03, 37.04 **UNKNOWN** Unknown Nov-02

38.01 **HAHA** Hosier Ln Jul-03, 38.02 **Various** Electric Ln Feb-03, 38.03 **MONKEY** Hosier Ln Jul-03, 38.04 **HAHA** Electric Ln Feb-03, 38.05 **Various** Canada Ln May-03

39.01 **UNKNOWN** Canada Ln May-03, 39.02 Canada Ln May-03, 39.03 Canada Ln May-03, 39.04 Canada Ln May-03, 39.05 Canada Ln May-03, 39.06 Canada Ln May-03, 39.07 **CIVIL** Canada Ln May-03, 39.08 **Toasters** Unknown Dec-02, 39.09 **CIVIL** Northcote Mar-03, 39.10, Northcote Mar-03, 39.11 Richmond Apr-03, 39.12 Richmond Apr-03, 39.13 **Toasters** Unknown Dec-02, 39.14 Unknown Dec-02

40.01 **HAHA** Richmond Apr-03, 40.02 Northcote High St Mar-03, 40.03 Lonsdale St Jun-02, 40.04 Brunswick Apr-04, 40.05 Northcote High St Mar-03, 40.06 Richmond Apr-03

41.01 **HAHA** Melbourne CBD Feb-03, 41.02 Fitzroy Aug-02, 41.03 Centre Pl Aug-02, 41.04 Carlton May-03, 41.05 Unknown Jun-03, 41.06 Centre Pl Jun-04, 41.07 Northcote High St Mar-03, 41.08 Richmond Apr-03, 41.09 Richmond Apr-03, 41.10, Richmond Dec-03, 41.11 Hosier Ln May-03, 41.12 Centre Pl Jun-04, 41.13 Richmond Apr-03, 41.14 Melbourne CBD Jul-03, 41.15 Melbourne CBD Feb-03, 41.16 Brunswick Jun-02

42.01 **DLUX** Little Lonsdale St Mar-03, 42.02 Melbourne CBD Feb-03, 42.03 Melbourne CBD Dec-03, 42.04 Duckboard Pl Mar-03, 42.05 Brunswick Apr-03, 42.06 Fitzroy Apr-03, 42.07 Fitzroy Apr-03

43.01 **DLUX** Centre Pl Aug-02, 43.02 Richmond Apr-03, 43.03 Richmond Apr-03, 43.04 Brunswick Apr-03, 43.05 Corporation Ln Mar-03, 43.06 Carlton May-03, 43.07 Richmond May-03, 43.08 Hosier Ln Aug-02

44.01 **RONE** St Kilda Jn Apr-05, 44.02 St Kilda Jn Apr-06, 44.03 **MONKEY** Hosier Ln Apr-04, 44.04 Hosier Ln Jun-04

45 **RMIT** Hosier Ln Sep-04

46.01 **VEXTA** Centre Pl Jun-04, 46.02 **CIVIL** Melbourne Suburbs Jul-03, 46.03 **Cycle couriers** Melbourne CBD Mar-04

47.01 **TINAP** Centre Pl Sep-04, 47.02 Centre Pl Sep-04, 47.03 Centre Pl Sep-04 **ARYZE** Centre Pl Sep-04, 47.04 Centre Pl Sep-04, 47.05 **RMIT** Hosier Ln Sep-04, 47.06 Hosier Ln Sep-04, 47.07 Hosier Ln Sep-04, 47.08 Hosier Ln Sep-04

48.01 **ARYZE** Hosier Ln Jun-04, 48.02 **UNKNOWN** Hosier Ln Apr-04, 48.03 Melbourne CBD May-04, 48.04 **UNKNOWN** Little Bourke St Dec-03, 48.05 **UNKNOWN** Hosier Ln Jun-04, 48.06 Hosier Ln May-04

49.01 **JADE** Prahran Jan-04, 49.02 Collingwood Aug-03, 49.03 **MONKEY** Melbourne CBD Feb-04, 49.04 Canada Ln May-04

50.01 **UNKNOWN** Canada Ln Jun-03, 50.02 **MONKEY** Hosier Ln Jun-04, 50.03 Hosier Ln Jun-04, 50.04 **UNKNOWN** Canada Ln Jun-03, 50.05 Canada Ln Jun-04, 50.06 Canada Ln Jun-03

51.01 **UNKNOWN** Northcote Mar-03, 51.02 Northcote Mar-03

52.01 **UNKNOWN** Hosier Ln Jun-04, 52.02 Hosier Ln Jun-04, 52.03 Hosier Ln Jun-04, 52.04 Hosier Ln Jun-04

53 **TIM** Canada Ln May-04

54.01 **UNKNOWN** Melbourne CBD Jun-03, 54.02 **CITYLIGHTS** Hosier Ln unknown, 54.03 **HAHA** Canada Ln May-03, 54.04 **UNKNOWN** Canada Ln May-03, 54.05 **SYNC** Melbourne CBD Jun-03, 54.06 Unknown Nov-02, 54.07 **OPTIC** Melbourne CBD Jun-03, 54.08 Melbourne CBD Jun-03, 54.09 **UNKNOWN** Oliver Ln Aug-02, 54.10, **SYNC** Melbourne CBD Jun-03, 54.11 Melbourne CBD Jun-03, 54.12 **PHIBS** Electric Ln Jan-03, 54.13 Electric Ln Jan-03

55 **UNKNOWN** Oliver Ln May-02

56.01 **UNKNOWN** Unknown Nov-02, 56.02 **Egghead** Unknown Nov-02, 56.03 **PRISM** Caulfield East Jun-03, 56.04 Caulfield East Jun-03, 56.05 **REKA** Oliver ln Apr-04, 56.06 Oliver ln Apr-04, 56.07 **KOAN** Flinders Ln Apr-04, 56.08 Flinders Ln Apr-04, 56.09 **UNKNOWN** Flinders Ln Apr-04, 56.10, **8175** Flinders Ln Apr-04, 56.11 **PSALM** Hosier Ln unknown

57.01 **SAFARI** Hosier Ln Jun-04, 57.02 Hosier Ln Jul-04, 57.03 Hosier Ln Jun-04, 57.04 **HAHA** Hosier Ln Jun-04

58.01 **UNKNOWN** Hosier Ln May-03, 58.02 Flinders Ln May-03

59.01 **HAHA** Little Latrobe St Jul-04, 59.02 **KOAN** Flinders Ln Dec-03, 59.03 **SYNC** Hosier Ln Jul-03, 59.04 Little Latrobe St Jul-04, 59.05 **EGGHEAD** Hosier Ln Apr-04, 59.06 **URBAN** Oliver ln Apr-04, 59.07 **OPTIC** Little Latrobe St Jul-04, 59.08 **PSALM** Little Latrobe St Jul-03, 59.09 **RONE** Little Latrobe St Jul-04, 59.10, **MEEK** Oliver ln Apr-04, 59.11 **UNKNOWN** Hosier Ln Apr-04

# Pictography - IV

60.01 **MONKEY** A'Beckett St Feb-03, 60.02 **REGULAR PRODUCT** Melbourne CBD Jul-04, 60.03 **UNKNOWN** Caledonian Ln Jun-04, 60.04 Caledonian Ln Jun-04, 60.05 **MILES** Caledonian Ln Jun-04, 60.06 **SOUL** Caledonian Ln Jun-04, 60.07 **UNKNOWN** Caledonian Ln Jun-04, 60.08 Chapel St Sep-04

61.01 **NUMSKULL** Flinders Ln Jun-04, 61.02 Hosier Ln Jun-04, 61.03 Sutherland St Jun-04, 61.04 Hosier Ln Jun-04

62.01 **KOAN** Flinders Ln Dec-03, 62.02 **UNKNOWN** Hosier Ln May-03

63.01 **UNKNOWN** Caledonian Ln Jun-04, 63.02 **PSALM** Little Latrobe St Jul-04, 63.03 **UNKNOWN** Oliver Ln Jul-04, 63.04 DuckBoard Pl Mar-03, 63.05 **ARYZE** Hosier Ln Sep-04, 63.06 **UNKNOWN** Elizabeth St Jun-04, 63.07 **SNOG** Elizabeth St Jun-04, 63.08 **DR FORBODE** A'Beckett St Feb-03, 63.09 **UNKNOWN** Caledonian Ln Jun-04, 63.10, **ARYZE** Hosier Ln Sep-04, 63.11 Hosier Ln Sep-04, 63.01 **EMDESE** Hosier Ln Jul-03

64.02 **TUSK** Little Latrobe St Jul-04, 64.03 **UNDENK** Hosier Ln Sep-04, 64.04 **UNKNOWN** Little Latrobe St Feb-03, 64.05 Little Latrobe St Feb-03, 64.06 Hosier Ln Sep-04, 64.07 **YOK** Hosier Ln Jul-04, 64.08 **YOK** Little Latrobe St Feb-03, 64.09 **UNKNOWN** Hosier Ln Sep-04, 64.10, **EMDESE** Hosier Ln Sep-02

65 **PSALM** Flinders Ln Jul-04

66 **PHIBS** Elizabeth St Feb-03

67 **PHIBS, REKA, WONDERLUST, NUEROC, RONE, LISTER, MEGGS, PRISM and SYNC** Hosier Ln Sep-04

68.01 **SYNC** Melbourne CBD Dec-03, 68.02 Caledonian Ln Feb-05, 68.03 Melbourne CBD Mar-04, 68.04 Melbourne CBD Feb-03, 68.05 Richmond Feb-04, 68.06 Little LaTrobe St Mar-04, 68.07 Little LaTrobe St Mar-04, 68.08 Little Lonsdale St Mar-04, 68.09 Little Lonsdale St Mar-04, 68.10, Little Lonsdale St Mar-04, 68.11 Caulfield Line Feb-05, 68.12 Caledonian Ln Feb-05

69.01 **SYNC** Collingwood Jan-05, 69.02 Richmond Jan-05, 69.03 Richmond Jan-05, 69.04 Abbotsford Jan-05, 69.05 Richmond Jan-05, 69.06 Richmond Jan-05

70.01 **Various** Little Lonsdale St Mar-04, 70.02 Hosier Ln Jan-05

71.01 **AL STARK** Hosier Ln Jul-04, 71.02 **UNKNOWN** Unknown Nov-02, 71.03 **KO-OP** Brunswick Apr-03, 71.04 **UNKNOWN** Alexander Pde Jul-02, 71.05 **RANSOM** Hawksburn Stn Jun-03, 71.06 **WUC** Clarendon St Jun-04

72.01 **UNKNOWN** Little Collins St Jul-02, 72.02 Richmond Jun-03, 72.03 Flinders Ln Jun-02

73.01 **UNKNOWN** Yarra Trail Jun-03, 73.02 Fitzroy Jun-02, 73.03 **AARON** Coburg Jun-03, 73.04 **UNKNOWN** Richmond Jul-03

74.01 Unknown Nov-02, 74.02 Coburg Jun-03, 74.03 Fitzroy Jun-03, 74.04 Collingwood Jul-03, 74.05 Canada Ln Jun-03, 74.06 **ZOMBIE** Riversdale Mar-03, 74.07 **UNKNOWN** Mckillop St Sep-02, 74.08 Fitzroy Mar-03, 74.09 Collingwood Jul-03, 74.10, Unknown Nov-02, 74.11 Collingwood Jul-03

75.01 **UNKNOWN** Unknown Nov-02, 75.02 McKillop St Jan-02, 75.03 Prahran Jul-02, 75.04 Prahran Jul-02, 75.05 Prahran Jul-02, 75.06 Fitzroy Jun-03, 75.07 Little Collins St Aug-02, 75.08 Unknown Nov-02, 75.09 Unknown Nov-02, 75.10, Carlton May-03

76.01 **UNKNOWN** Carlton Jul-03, 76.02 Hosier Ln Sep-04, 76.03 Hosier Ln Sep-04

77.01 **PRISM** Hosier Ln Sep-04, 77.02 **MONKEY** Hosier Ln Sep-04, 77.03 **MTED** Flinders Ln Sep-04, 77.04 **UNKNOWN** Hosier Ln Sep-04

78.01 **Various** Malvern Stn Sep-01, 78.02 **UNKNOWN** Caulfield East Mar-04, 78.03 Caulfield East Mar-04, 78.04 Caulfield East Mar-04, 78.05 Caulfield East Mar-04, 78.06 **SHINE** Bourke St Mar-03, 78.07 Bourke St Mar-03, 78.08 **MIC24** Bourke St Mar-03, 78.09 **UNKNOWN** Unknown Dec-02

79 **RENKS, CARL** 560 Bourke St Apr-05

80.01 **JF** Caledonian Ln Jul-04, 80.02 **XERO** Williams St Jun-04, 80.03 **EGGHEAD** Lonsdale St Jun-04, 80.04 **SIZXTEN. HAHA** Sutherland St Jun-03, 80.05 **DEVIANT** Caledonian Ln Jul-04, 80.06 **MONKEY** Sutherland St Mar-03, 80.07 **SIXTEN** Little Lonsdale St Feb-03, 80.08 Little Lonsdale St Feb-03, 80.09 Little Lonsdale St Feb-03, 80.10, Little Lonsdale St Feb-03, 80.11 Little Lonsdale St Feb-03, 80.12 Little Lonsdale St Feb-03, 80.13 Sutherland St Mar-03

81.01 **SCWIGGLER** Seaford Aug-03, 81.02 Malvern Sep-, 4, 81.03 Malvern Jul-04, 81.04 Richmond Jul-04, 81.05 Flinders St Sep-04, 81.06 Malvern Jul-04, 81.07 **UNKNOWN** Elizabeth St Jul-04, 81.08 Spencer St Jul-04, 81.09 Bourke St Jul-04, 81.10, Sutherland St Mar-04, 81.11 **DEVIANT** Sutherland St Mar-04, 81.12 **SCWIGGLER** Armadale Sep-04

82.01 **UNKNOWN** Melbourne CBD Mar-04, 82.02 **FERS** Melbourne CBD Oct-04, 82.03 Melbourne CBD Nov-04, 82.04 **EGGHEAD** Melbourne CBD Mar-04, 82.05 **UNKNOWN** Melbourne CBD Mar-04, 82.06 Melbourne CBD Mar-04, 82.07 Melbourne CBD Mar-04

83.01 **PILFER** Armadale Mar-05, 83.02 **UNKNOWN** Smith St Sep-04, 83.03 **KOUK** Carnegie Feb-05, 83.04 **SCMEK** Swan St Apr-05, 83.05 **UNKNOWN** Smith St Sep-04, 83.06 Brunswick St Nov-04

84.01 **TUSK** Northcote Dec-04, 84.02 **OMSK** Northcote Dec-04, 84.03 **NOKIA** Northcote Dec-04, 84.04 **OPTIC** Hosier Ln Sep-04, 84.05 **DSURE** Hosier Ln Sep-04, 84.06 **POLLEN** Hosier Ln Sep-04, 84.07 **PRISM** Hosier Ln Sep-04, 84.08 **NOKIA** Northcote Dec-04

85.01 **HAHA** Collingwood Nov-04, 85.02 **REKA, PRISM** Collingwood Nov-04, 85.03 **NAILS** Collingwood Nov-04, 85.04 **SWIGS, TUSK, GODZILLA** Collingwood Nov-04, 85.05 **REKA** Collingwood Sep-04, 85.06 **GLYPH** Hosier Ln Sep-04

86.01 **PEAZOR** Collingwood Sep-04, 86.02 Collingwood Sep-04, 86.03 Collingwood Sep-04, 86.04 Collingwood Sep-04

87.01 **OPTIC** Northcote Jul-04, 87.02 Northcote Jul-04, 87.03 Northcote Jul-04, 87.04 Northcote Jul-04

88.01 **SEDAZ** Hawksburn Jul-04, 88.02 **ONCE** Hawksburn Jul-04, 88.03 **VK** Hawksburn Jul-04, 88.04 **AKNI** Hawksburn Jul-04, 88.05 **HEK** Hawksburn Jul-04, 88.06 **MEARA** Hawksburn Jul-04, 88.07 **INFS** Richmond Jul-04, 88.08 **NAILS** Fitzroy Jul-04, 88.09 **SAIPAN** Northcote Jul-04, 88.10, **TECHNO** Northcote Jul-04, 88.11 **TECHNO** Northcote Jul-04, 88.12 **SWIGS** Hawksburn Jul-04, 88.13 **FLOWE** Hawksburn Jul-04, 88.14 **SEDAZ** Hawksburn Jul-04

89.01 Fitzroy Sep-04, 89.02 **CARL** Collingwood Sep-04, 89.03 **BONES** Collingwood Sep-04, 89.04 **CARL** Fitzroy Sep-04, 89.05 **VESPA** Collingwood Sep-04, 89.06 **SPC** Fitzroy Sep-04

90.01 **SWIGS** Unknown Nov-04, 90.02 **UNKNOWN** Unknown Nov-04, 90.03 **DAMMIT, NEXT** Fitzroy May-02, 90.04 **MIKE**

BROWN Clifton Hill May-03

91.01 **UNKNOWN** Collingwood May-02, 91.02 **BAILER** Unknown Sep-02, 91.03 **NOKIA** Northcote Mar-03, 91.04 **PUZLE** Prahran Sep-02, 91.05 **BINGE** Burnley Mar-04, 91.06 PHIBS, REKA, SYNC May 05, 91.07 **BAILER** Port Melbourne Sep-04, 91.08 **DENS, REACH, NASTY** Fitzroy Aug-02, 91.09 **UNKNOWN** Malvern Aug-02, 91.10, **UNKNOWN** Unknown Aug-03

92-93 **NOMAD, DSCREET, UNKNOWN, IREE, UNKNOWN, AMBUSH, METER** Northcote Mar-03

94-95 **Sumo, Artist Supplied.**

96.01 **VOF** Burnley Stn Jun-03, 96.02 **JORS** Armadale Jun-03, 96.03 **DIZZY** Caulfield Jul-04, 96.04 **SHARP** Caulfield Jul-04, 96.05 **NOMAD** Northcote Mar-03, 96.06 **SHARP** Caulfield Jul-04, 96.07 **UNKNOWN** Carnegie Mar-03, 96.08 **OILEM** Richmond Jul-04, 96.09 **DV8** Caulfield Jul-04

97.01 **MUCK** Malvern Mar-04, 97.02 **COYOTE** Armadale Jul-04, 97.03 **NEON, WITH** Richmond Jul-04, 97.04 **SDM (Swet Da Met), DV8** Caulfield Jul-04, 97.05 **KC** Armadale Jul-03, 97.06 **UNKNOWN** Prahran Jan-04, 97.07 **MARINE** Prahran Jan-04, 97.08 **UNKNOWN** Richmond Jul-03, 97.09 **METHOD** Richmond Jul-03

98.01 **UNKNOWN** Burnley Stn Jul-04, 98.02 Centre Pl Feb-05, 98.03 Burnley Stn Jul-04, 98.04 **PLEA** Unknown Nov-02

99.01 **UNKNOWN** Unknown Nov-02, 99.02 Murrumbeena Dec-03, 99.03 **SEMI** Richmond Apr-03, 99.04 **UNKNOWN** Collingwood Feb-05, 99.05 **COYOTE** Bentleigh Dec-03, 99.06 **UNKNOWN** Melbourne CBD Aug-03, 99.07 Bentleigh Dec-03, 99.08 Unknown Nov-02

100.01 **DSCREET** Fitzroy Feb-05, 100.02 **DVATE** Abbotsford Feb-05, 100.03 **TUSK** Abbotsford Feb-05, 100.04, Unknown, Burnley Stn, Jul 04, 100.05, CBD, 2004, 100.06 **SNUFF** Clifton Hill Feb-05, 100.07 **KAB**, CBD, June 04

101.01 **UNKNOWN** Carnegie Dec-03, 101.02 Carnegie Dec-03, 101.03 Carnegie Dec-03, 101.04 **ALISTAIR** Fitzroy Feb-05, 91.05 Fitzroy Feb-05, 101.06 Fitzroy Feb-05, 101.07 **UNKNOWN** Carnegie Dec-03, 101.08 Carnegie Dec-03

102.01 **CANTWO** Murrumbeena Dec-03, 102.02 Murrumbeena Dec-03, 102.03 Murrumbeena Dec-03, 102.04 **INPAC** Carnegie Dec-03, 102.05 **PLEA** Murrumbeena Dec-03, 102.06 Murrumbeena Dec-03, 102.07 Murrumbeena Dec-03, 102.08 **SCWIGLE** Prahran Sep-02, 102.09 **UNKNOWN** Burnley Jun-03, 102.10, Fitzroy Jul-03

103.01 **TRIALS** Richmond Aug-03, 103.02 **UNKNOWN** Fitzroy Sep-03, 103.03 **POKS (Perks & Mini)** Melbourne Suburbs Aug-02, 103.04 **MESK** Collingwood Jul-03, 103.05 **GRATE** Melbourne Suburbs Aug-02, 103.06 **INPAC** Melbourne Suburbs Aug-02, 103.07 **PARIS** Melbourne CBD Jun-03, 103.08 **YODA** Collingwood Sep-02, 103.09 **REAKT** Yarra Trail Sep-03, 103.10, **TRANCE** Melbourne Suburbs Aug-02, 103.11 **PUZLE** Prahran Jan-04

104.01 **UNKNOWN** Unknown Nov-02, 104.02 **PEP** Fitzroy Mar-04, 104.03 **SOLE** Brunswick Feb-04, 104.04 **KIS** Unknown Nov-02, 104.05 **SIZLE** Northcote Mar-03, 104.06 **WCA** Yarra Trail Sep-03, 104.07 **MKA** Bentleigh Dec-03

105.01 **DSCREET** Carnegie Dec-03, 105.02 **DUEL** Burnley Jun-03, 105.03 **DSCREET** South Yarra Jul-03, 105.04 **GRATER** Burnley Stn Jun-03, 105.05 **UNKNOWN** South Yarra Jul-03, 105.06 South Yarra Jul-03, 105.07 **ISLE** Frankston Jan-04, 105.08 **UNKNOWN**

# Pictography - V

Yarra Trail Sep-03, 105.09 **BINGE** South Yarra Jul-03, 105.1 **REACH** Burnley Jun-03

106.01 **SWINE** Burnley Jun-03, 106.02 **UNKNOWN** Burnley Jun-03, 106.03 Burnley Jun-03, 106.04 **YVETTE** Burnley Jun-03, 106.05 **IREE** Carnegie Dec-03, 106.06 **TRIMS** Burnley Jun-03, 106.07 **DVATE** Burnley Jun-03

107.01 **PHIBS** Collingwood Sep-03

108.01 **HPOD** Melbourne Suburbs Jul-03, 108.02 **UNKNOWN** Melbourne Suburbs Jul-03, 108.03 **WITH** Burnley , tn Jun-03, 108.04 **UNKNOWN** Frankston Jan-04

109.01 **MINI ME** Burnley Jun-03, 109.02 **PLEA** Murrumbeena, Aug-03, 109.03 **STICK UP KIDS** Murrumbeena Aug-03, 109.04 **UNKNOWN** Carnegie Dec-03, 109.05 Carnegie Jan-03, 109.06 **PHIBS** Melbourne CBD Feb-03, 109.07 **UNKNOWN** Carnegie Dec-03, 109.08 Melbourne Suburbs Jul-03, 109.09 **CANTWO** Carnegie Dec-03

110.01 **CTM** Malvern Sep-02, 110.02 **SDM** Malvern Sep-02, 110.03 **SIOR** Malvern Sep-02, 110.04 **MUTATE** Malvern Sep-02, 110.05 **AIMS** Malvern Sep-02, 110.06 **FLINT** Malvern Sep-02, 110.07 **DRASTIC** Malvern Sep-02, 110.08 **CARGOE** Malvern Sep-02

111.01 **RIDL** Northcote Mar-03, 111.01 **CARL** South Yarra May-04, 111.01 **UNKNOWN** Richmond May-04, 111.01 Richmond May-04

112 **PHIBS** Malvern Jul-04,

113 **LEMON** Hosier Ln Sep-03

114.01 **SHIME** Murrumbeena Dec-03, 114.02 **CANTWO** Murrumbeena Dec-03

115 **CIVIL, NED** Coburg Sep-03

116-119 **MIC** Melbourne CBD 2002-2005

120 **Reka** Artist Supplied, Melbourne Railways 2005

121 **Reka** 1, 2, 3, 5, 6, 8 Artist Supplied, Melbourne Railways 2005

122.01 **SYNC, REKA** Melbourne Railways Mar-05, 122.02 **REKA, PRISM** Melbourne Railways Mar-05, 122.03 **SYNC, PRISM** Melbourne Railways Mar-05, 122.04 **PRISM** Melbourne Railways Mar-05

123.01 **PRISM, HAILLE, REKA** Melbourne Railways Mar-05, 123.02 **SYNC, PRISM** Melbourne Railways Mar-05, 123.03 **SYNC, REKA, PRISM** Artist Supplied, Melbourne Railways 2005, 123.04 **SYNC, REKA** Artist Supplied, Melbourne Railways 2005, 123.05 **MIC, HAILE** Melbourne Railways Mar-05, 123.06 **SYNC, REKA** Artist Supplied, Melbourne Railways 2005

124-125 **GHOSTPATROL** Artist Supplied 2000-2005

126-127 **HAYDEN DEWAR** Richmond 2003-2005

128 **CKAUV, PAVRE, ELRONE, DUET, DMA, BURN, AEON, HENRY, SUB, ZODE, META** Richmond Jun-03

129.01 **MIC** Hosier Ln Sep-04, 129.02 **UNKNOWN** Melbourne CBD Jun-03, 129.03 **MIC** Hosier Ln Jun-04, 129.04 **UNKNOWN** Richmond Stn Sep-02, 129.05 **MIC** Hosier Ln Apr-04, 129.06 **UNKNOWN** Collingwood Jun-03, 129.07 Hosier Ln Apr-04, 129.08 Hosier Ln Jun-04

130 **DEST** Melbourne CBD Dec 04-Jan 05

131 **MINIGRAFF** Duckboard Pl Mar-03

132.01 **UNKNOWN** Richmond Stn Jul-04, 132.02 Richmond Stn Jul-04, 132.03 Melbourne Zoo, Mar-04

133.01-3 and .05 **UNKNOWN** Various points in Melbourne inc. Nicholson Street, Neerim Rod and Glenhuntly Road, 133.04 Canada Ln, Jan-05

134.01 **UNKNOWN** Richmond Stn Jul-04, 134.02

Neerim Rd Dec-03, 134.03 Country Victoria Nov-04

135 **UNKNOWN** Melbourne CBD

143 **CIVIL, NED** Coburg Sep-03

# Further Reading

## Graffiti Collectives:

| | |
|---|---|
| www.woostercollective.com | Excellent value collection of information and artists, arguable the most comprehensive listing available. |
| www.puregraffiti.com | Comprehensive coverage of graffiti |
| http://www.freshsites.com/ | Large graffiti collection |
| http://www.syntac.net/hoax/vandalism.php | Large graffiti collection |
| http://www.graffiti.org | Comprehensive site |
| http://www.bombhiphop.com/graf2.htm | Global gallery |
| www.counterproductiveindustries.com/gbgc | God Bless Graffiti Coalition, a pro-graffiti organization |
| www.picturesofwalls.com | Pictures Of Walls |
| www.ekosystem.org | A Street-art portal |
| www.crcstudio.arts.ualberta.ca/scrawl | Collection of street art from around the world |
| www.streetmemes.com | Stickers, stencils and posters. |
| streetart.antville.org | Collaborative weblog for photos of graffiti |
| http://subvertise.org | Anti-advertising |
| www.krita.com/graf/1.html | Collection of Graffiti related data |
| www.rebelart.net/i0004.html | The art of urban warfare |

## Melbourne Graffiti Directories:

| | |
|---|---|
| www.stencilrevolution.com | Biggest Stencil community on the web |
| www.stateofflux.com | Melbourne Street Art collection |
| www.stickernation.com.au | Stickers, posters and more. |
| http://pbp.no-ip.com | Puffing Billy Posse |
| www.melburngraf.tk | Melburne Graf Culture |
| www.dahub.com.au/dahub | Da Hub, A key Australian graff site |
| www.stencilgraffiticapital.com | Melbourne Stencils |
| www.melbournegraffiti.com | Over 4,000 images, (walls, trains, memes, tags, throwups) |
| www.geocities.com/gs38_f4 Melbourne | Grand Sorcerer Thirty-Eight -the original graffer |
| www.melburners.blogspot.com | Graffiti Melbourne/ Eastern Suburbs |
| www.iol.ie/%7Ehandjobs | Melbourne Tags |
| www.fatbombers.com/public/wp | Bombing site |
| www.stencilfestival.com | Melbournes Stencil Festival |

## Magazines:

| | |
|---|---|
| www.at149st.com/zines.html | Magazine listings |
| www.acclaimmag.com | Acclaim Magazine |
| www.aktifmag.com | Melbourne graff magazine |
| www.out4fame.com.au | Out4Fame Magazine Online |
| www.adbusters.org | Leading culture jammers magazine |

## Artists:

| | |
|---|---|
| ARYSE | www.fotolog.net/aryse |
| GHOSTPATROL | www.ghostpatrol.net |
| LISTER | www.listerart.com.au |
| PHIBS | www.phibs.com |
| PSALM | www.psalm.com.au |
| REKA ONE | www.fotolog.net/rekaone or www.rekaone.com/news.html |
| TUSK | www.tuskmedia.com.au |
| YOK | www.theyok.com |

## Books:

| | |
|---|---|
| **Graffiti World : Street Art from Five Continents** | Nicholas Ganz, Harry N Abrams 0810949792, (October 26, 2004) |
| **Stencil Pirates: A Global Study of the Street Stencil** | Josh MacPhee Soft Skull Press , 1932360158 (2004) |
| **Street Logos** | Tristan Manco Thames & Hudson, 500284695 (2004) |
| **Stencil Graffiti** | Tristan Manco Thames and Hudson, 0-500-28342-7, (2002) |
| **Broken Windows Graffiti NYC** | James Murray, Karla Murray Ginko Press (USA), 1-58423-078-9 (2002) |
| **Stickers : Stick Em' Up** | Mike Dorrian, David Recchia, Booth Clibborn 0186154247X, (2002) |
| **Subway Art** | Henry Chalfont and Martha Cooper Thames and Hudson. 0-500-27320-0 1984, 1987 |
| **Spraycan Art** | James Prigoff Henry Chlafant Thames & Hudson. 0-500-27469-X 1987, 1994 |
| **Soho Walls: Beyond Graffiti** | David Robinson Thames and Hudson, 1990 |

# Further Reading

## How To:

| | |
|---|---|
| Avoid getting caught | www.powderbomb.com/modules.php?name=Content&pa=showpage&pid=1 |
| Create a basic stencil cut | www.stencilrevolution.com/tutorials/tutorialsview.php?id=1 |
| Converting a colour photo to a single layered stencil with Photoshop | www.stencilrevolution.com/tutorials/tutorialsview.php?id=4 |
| Creating a 3 layer multicolour stencil | www.stencilrevolution.com/tutorials/tutorialsview.php?id=6 |
| Using chalk for your stencils | www.stencilrevolution.com/tutorials/tutorialsview.php?id=5 |
| How to make your very own stencil caps | www.freshsites.com/stencil_cap_tutorial.asp |
| How to mix paint | www.freshsites.com/mixing_spraypaint.asp or http://www.edksite.com/act/mix/ |
| Making your mural last: Graffiti, Varnish and Wall Chemistry | www.bok.net/~jig/mural/muralprep.html |
| Protect yourself from volatile organic compounds | www.graffiti.org/faq/masks.html contains more information on the subject and recommends that spray painters wear a filter mask when painting |

## Newspapers:

Search each newspaper dividually, and you will find dozens of graffiti and street art related articles and snippets of information. The Age Newspaper (www.theage.com.au) returns typically between 50-100 articles.

## Film:

| | |
|---|---|
| Style Wars, 1983 | Directed by Tony Silver, Produced by Henry Chalfant. Represents a history of the 1980s NYC graffiti scene www.imdb.com/title/tt0177262 |
| Wild Style, 1982 | Directed by Charlie Ahearn, the first Hip hop movie www.imdb.com/title/tt0084904 |
| Beat Street, 1984 | Directed by Stan Lathan, produced by Harry Belafonte and David V. Picker. A drama that takes place in the emergent hip-hop scene of early 1980s New York City www.imdb.com/title/tt0086946 |
| Turk 182 (1985) | A fictional account of graffiti used for political purposes in New York City. The name might be a reference to TAKI 183 www.imdb.com/title/tt0090217 |
| Bombing British Channel 4 | Documentary featuring many UK and U.S. graffiti artists in the early to mid eighties No URL available |

## Other Sources of Interest:

| | |
|---|---|
| Paper summarising 'piecing' | www.oneeighthree.com/html/kasinomasterpaper/paper.htm |
| Graffiti Culture Research Project, by Mark Halsey and Alison Young | www.kesab.asn.au/graffiti/ |
| Graffiti Language | www.crispinsartwell.com/grafflang.htm |
| True type graffiti fonts for download. | www.graffitifonts.com/ and photofreaks.tripod.com/banner/id1.html |
| Site devoted to promoting graffiti as an art form. Includes photos and interviews | www.x2project.com |
| Create your own graffiti | www.graffiticreator.net |
| A Graffiti glossary at Artcrimes.org | www.artcrimes.org/faq/graffiti.glossary.html |
| General reference | http://en.wikipedia.org/wiki/Graffiti |
| Australian online store (highest quality graffiti related books, magazines, dvds and videos directly to your door) | www.finaloutline.com |
| Comic books and occasional graffers | www.silentarmy.com |
| Cave Clan, Melbourne's underworld explorers | www.caveclan.org |
| Graffiti Bibliography | www.nycsubway.org/biblio/art.html |

The irony with street art and the romanticising press coverage that it receives in Melbourne is that the boundaries of legal and illegal art become blurred. Local authorities spend significant time, effort and money banning all forms of street art, and condemn writers for creating it while other institutions spend time and money promoting it. It is a contradictory situation, one that is bound to confuse.

The street art scene is typically populated by teenagers, a rebellious stage of life and one where we grapple with the realities of life and define our values and beliefs. The reality is that Street Art can not be washed out of existence by rules, it may only wax and wane according to local policies, and the writers themselves will come and go.

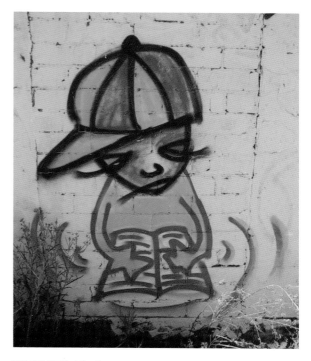

First published in Australia in 2006 by Craftsman House

An imprint of Thames and Hudson Australia Pty Ltd,

Portside Business Park, Fishermans Bend, Victoria, 3207

www.thamesandhudson.com

ISBN 0 9757 684 1 7

CIP Data

Lunn, Matthew James.

  Street art uncut.

  Bibliography.
  Includes index.
  ISBN 0 9757684 3 3.

  1. Street art - Victoria - Melbourne. I. Title.

  751.7309945

Design: Matthew Lunn

Production: Imago

Page-Make up Sarn Potter

Printed in Singapore

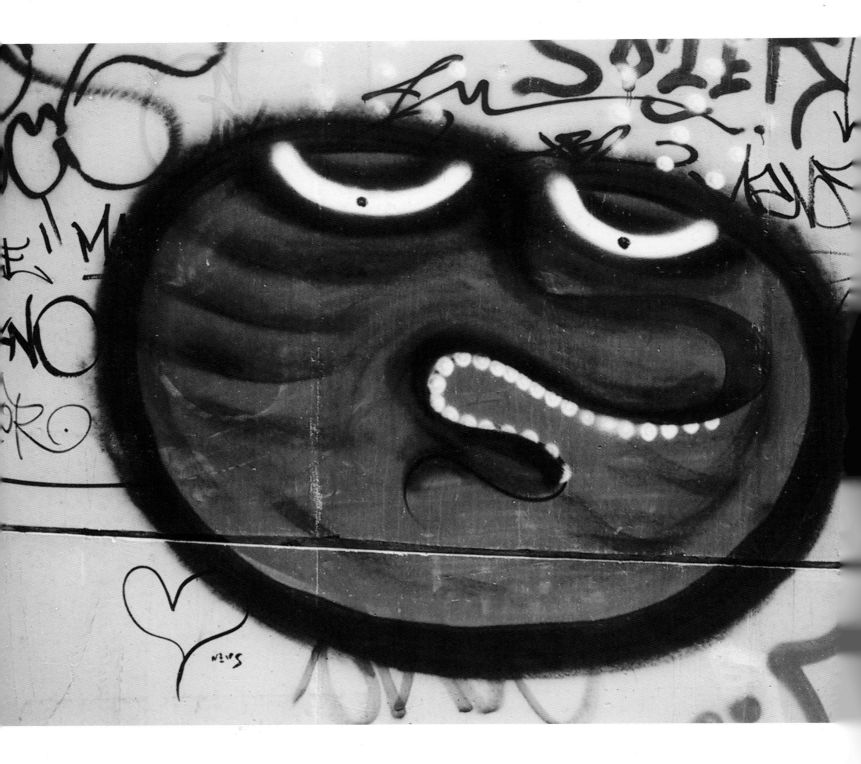